Wildflower Watercolor

The Beginner's Guide to Painting Beautiful Florals

SUSHMA HEGDE

PAGE STREET
PUBLISHING CO.

TO MY MOTHER, NIRMALA, WHO TAUGHT ME TO FIND JOY IN
THE LITTLE THINGS IN NATURE.

PAGE STREET
PUBLISHING CO.

Contents

Introduction

The beautiful and resilient wildflowers that grow next to roads or peek out of stone walls and crevices have always been an inspiration for me. During my early morning walks in the nearby forest and fields, I spend a lot of time spotting new wildflowers and herbs, while observing their colors and shapes. This process brings me immense joy and puts me in the right mindset to begin my day. I have always tried to capture this feeling in my creative process, in the form of wildflower dyes and inks, cyanotypes, herbal concoctions and, of course, paintings. My paintings reflect my appreciation of nature's beauty, imperfections and colors.

In this step-by-step workbook, we will create an array of wildflowers and flowering herbs using a range of techniques and colors. At the end of this book, we will also bring together some of the wildflowers to create bouquets in order to understand floral compositions.

As you dive into the book, you will see that instead of starting with a pencil sketch (which is a common approach), all of the flower paintings start directly with watercolors. This approach will help keep your brushstrokes loose and whimsical without being too restricted by pencil marks.

Remember that we are not trying to create photo-realistic images, but are instead giving the impression of flowers by focusing on their colors, shapes and sizes. We will try to embrace imperfections in our brushstrokes to add whimsy and movement to our paintings. Watercolors greatly help in this loose approach because of their fluidic nature and ease of movement on the paper. This will help us let go in the areas where we have no control over the painting and enjoy the spontaneity of the medium.

I hope this book acts as a springboard for your creative journey. It may sometimes push you out of your comfort zone, which is a good thing when you want to learn something new. When you think you have "failed" and want to give up, or when you are intimidated to start a painting, remember that the only thing you have to lose is a piece of paper, and then, start over.

There are endless ways of interpreting and painting flowers. Use this book as a guide to see some of the possibilities and learn the techniques involved. I hope this book encourages you to go out, explore and find what brings you joy and paint those flowers.

I would love to see what you create from this book. You can share your paintings with me on Instagram @sushhegde using the hashtag #wildflowerwatercolor.

Sushma Hegde

Supplies

Choosing the right materials may seem confusing for beginners. There are so many different kinds of brushes, paper and paints on the market that it gets really hard to pick the right tools that work for you. When you see that the artists you admire are all using different materials, it just adds to the confusion. Remember that each artist is different and has different preferences. What seems best for one artist may not be a good option for another.

To keep it simple, start with just a few basic supplies, and then slowly add new ones when you understand your painting style and want to try new things.

WATERCOLOR PAPER

Watercolor paper comes in a variety of textures, materials, thicknesses and forms, and every combination could give you a different result.

Texture

Fine grain paper that has a slight grainy texture on it works great for most watercolor techniques. I use cold press watercolor paper, which is also known as NOT in the UK (not hot pressed). This is fine-grain paper and works very well for painting loose flowers and landscapes.

Material

The most commonly used watercolor papers are made of cotton, cellulose or a mix of the two. I generally stick to 100 percent cotton paper, as it has great absorbency, and the paper stays wet for longer. This is very helpful when you want

to seamlessly blend two colors. A 50 percent, or more, cotton paper also works well for all the projects in this book.

Thickness

If you add too much water to thin paper, it might easily buckle and tear. I generally stick to 140lb (300gsm) paper or thicker, as it allows me to use plenty of water and does not buckle easily.

Form

The paper you use can be in the form of a sketchbook, a paper block or simply a singular piece of paper. I have used loose sheets of paper for all the projects in this book, but you can use whichever form you prefer.

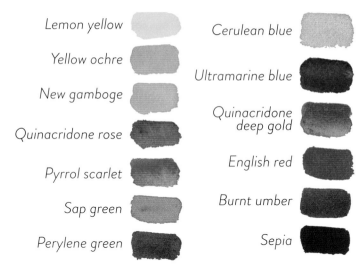

Lemon yellow

Yellow ochre

New gamboge

Quinacridone rose

Pyrrol scarlet

Sap green

Perylene green

Cerulean blue

Ultramarine blue

Quinacridone deep gold

English red

Burnt umber

Sepia

WATERCOLORS

If you are just getting started with watercolors, buy a set of artist-grade watercolors that contain two shades (warm and cool) of yellow, red and blue, and a few greens and browns. This will help you get started without overwhelming you with all the options that are available. Some of the artist-grade watercolors that I like are from the following brands: Daniel Smith, Schmincke, Winsor & Newton, White Nights Watercolors (formerly known as St. Petersburg Watercolors) and Sennelier.

You can buy watercolors in pans or tubes. They are the same, simply packaged in different ways. Choose whichever you like, based on your convenience. Watercolor pans are especially useful when you are traveling as they are light and fit compactly in a tin palette box. On the other hand, tubes are useful when you need lots of color, especially when you are painting on a large sheet of paper.

Above is a list of colors that I mostly use. You most certainly do not need so many colors, or even the exact same colors, to create a good painting. Use colors of your choice, or if you are not sure, choose colors close to those that I use.

BRUSHES

To paint flowers, I mostly use round and filbert brushes.

Round brushes are the most commonly used brushes with watercolors and are very versatile. I would suggest buying three or four round brushes of different sizes. These could be:

1. One small round brush for fine details, like a size 2 brush

2. One medium-sized round brush for the flowers and leaves, like a size 4 or a size 6 brush

3. One big round brush to add looser and bigger strokes, like a size 8 or a size 10 brush

You can get a variety of brushstrokes with these three brushes. Make sure that they have fine, sharp tips when you buy them.

Filbert brushes, also called oval brushes or cat's tongue brushes, are flat brushes with rounded or oval tips. With these brushes, you can get broad strokes with rounded ends, which is great for painting rounded petals like that of roses or aconites. When the brush is turned, the thinner side can be used to paint fine lines and to create a variety of leaves. I would recommend buying two filbert brushes of different sizes, one small (around size 6) and one big (around size 10).

The different ways of using round and filbert brushes are covered in detail in Basic Techniques (page 9).

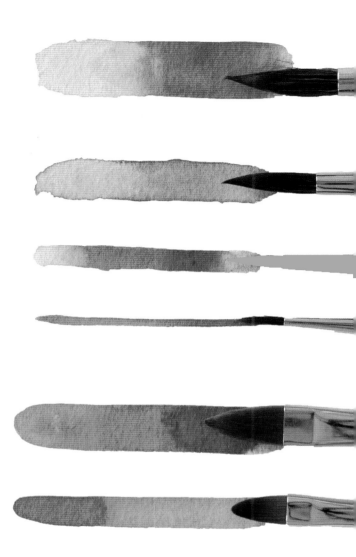

PALETTE

You will need a palette to mix different colors and add sufficient water to your color mixes. This could be a plate, a generic plastic palette with wells that can be found in all art stores or a ceramic palette.

Once the colors dry in your palette, you can reactivate and use them again by adding water.

WATER AND WATER CONTAINER

Watercolors in pans or tubes are too thick to be used directly on the paper. They need to be mixed with water before you start painting. I generally use old jam jars or ceramic cups to hold water. To avoid getting muddy colors, once the water in the jar looks murky, replace it with clean water. You can also use two jars of water simultaneously: one of them to clean your brushes and the other for your color mixes.

CLOTH OR PAPER TOWELS

Use an old cloth rag or a few paper towels to dab off excess paint from your brushes and to clean them while changing colors. A damp paper towel also works great for lifting off excess paint from the paper when needed.

WATERCOLOR PENCILS

When painting the correct shape of a flower or leaf seems tricky, you can first sketch light outlines with watercolor pencils. Since most watercolor pencils are water-soluble, once you start painting, pencil marks will gently blend with the rest of the paint.

Basic Techniques

Let me start by saying that there is no right or wrong technique for working with watercolors. As a beginner, all you need to know are the commonly used terms and a few basic techniques. You can use these as a starting point to familiarize yourself with the medium. Once you understand the basic techniques, you will be prepared to explore the medium and find ways to make it work for you, the way you want.

TONES OF A COLOR

Tone refers to how light or dark a color is. With watercolors, different tones of a color can be achieved by controlling the amount of water you mix with the paint without having to mix in white or black paint. The only thing you need to know is that if you add more water to the color, you get a lighter tone, and if you add less water, you get a darker tone.

WATER-TO-PAINT RATIO

Painting with watercolors is all about playing with water and colors. Sometimes you add more water, sometimes you add more color. It's all about finding the right balance.

The amount of water determines not just the tone, but it also changes the way your brush moves on the paper. Determining the correct water-to-paint ratio for a painting can be tricky, especially as a beginner. It takes some practice, exploration and lots of patience to determine what ratio suits your needs. It is also important to remember that different parts of the painting often require different water-to-paint ratios.

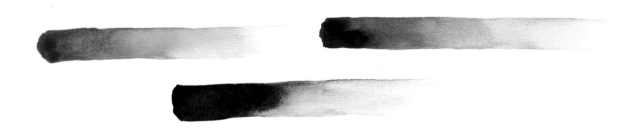

Here you can see the different tones of quinacridone rose, ultramarine blue and a purple mix of these two colors.

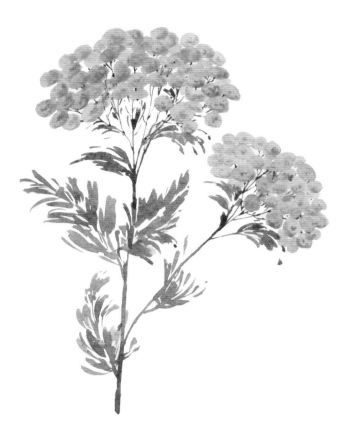

Here are some things to keep in mind while playing with different amounts of water and color:

1. Most artist-grade watercolors are highly pigmented and concentrated, which means you do not need lots of paint in your brush before mixing it with water. On your palette, start by mixing the color you want, little by little, with water. Add more color when you want a darker tone. If the color has become too dark, you can add more water to get a lighter tone.

2. Watercolors look darker when they are wet, and as they dry, they change to a lighter tone. This means you will have to paint slightly darker than what you have in mind for the finished painting. This way, once the painting dries, you will see the desired tone.

While painting the tansy flower, I have varied the tone of the yellow-brown mix by changing the amount of water to get lighter and darker tones. Similarly, to paint the leaves and stems, I have used the same green mix but varied the amount of water to get different tones of green.

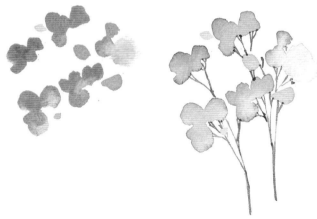

In this example, you can see the pink is dark when the color is still wet on the paper and shifts to a lighter pink when it dries.

COLOR MIXING

Now that we discussed mixing water with color, we can talk about mixing two or more colors together.

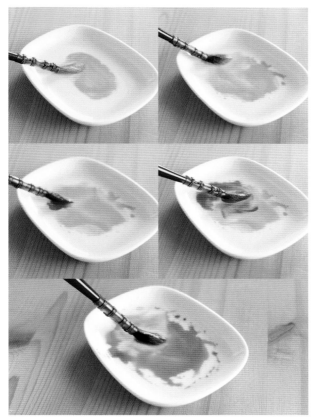

While mixing two colors, start with the lighter color first and keep adding the darker one until you get the desired color. Add water to adjust the tone of the color.

To mix two colors:

1. Using a clean damp brush, take the lighter color first.

2. Mix it with a small amount of water in the palette.

3. Start adding little drops of the darker color into this mix until you get the desired color.

4. Change the tone of the color by adding water (if you want a lighter tone) or adding more of the colors (if you want a darker tone).

Most watercolors, when directly used from the tube or pan, are too bright and intense and look very different from actual colors seen in nature. Instead of directly using these overly bright colors, I try to make them look earthier and closer to nature. To do this, I mix two or three colors together. For example, sap green directly used from the tube is very bright, and I prefer to add a bit of yellow ochre or quinacridone deep gold to get an earthy color.

sap green

sap green mixed with quinacridone deep gold

Having said that, in some cases where I need intense colors to show through the painting, I do prefer to use the colors directly from the tube. For example, while painting poppy or Indian paintbrush flowers, I use pyrrol scarlet directly from the tube to show the intense reds of these flowers on a sunny day.

MIXING WHITE

Painting white flowers can be very tricky with watercolors. Unlike acrylics or gouache, watercolors are a transparent medium, and the white of the paper shows through the colors in a painting. So, when you paint with white watercolor on a white paper, it is hardly seen. To give the effect of white, I generally use a very light brown or a very light gray mixed with lots of water. This helps to give subtle hints of white without dulling down the painting or making it muddy.

Depending on what white flowers you are painting, you can also use hints of the color of the stamen or the foliage in your white paint to help your flowers stand out on a white background. For example, in a daisy, the white petals are arranged around a prominent bright yellow center. In this case, adding a bit of yellow to the white not only helps make the flowers bright enough to pop out of the paper, but it also gives the painting a harmonious feel.

Another simple way to depict white is to add light outlines with a gray watercolor pencil. Since watercolor pencils are water-soluble, you can use a moist brush to spread this color gently over the rest of the flower.

MIXING GREEN

Nature is filled with different shades of green. To get the colors close to those appearing in nature, we don't need to buy every green available. We can try to mix them instead, with the colors already available in our palette.

A lot of my students mention that they find mixing greens very daunting. Sometimes the colors are too bright and unnatural, and sometimes they turn muddy and make the whole painting look dull. To avoid this, and to get rich, juicy, earthy greens, try this:

1. Primarily, I use two greens in my palette: sap green and perylene green. By adding a bit of blue, yellow or brown to these greens, I obtain a variety of colors.

2. Another trick that I generally use is to add a little bit of the color of the flower into the green. For example, if I am painting a red flower and the leaves are a dark green, I add a bit of the red to my sap green to get a warm, dark green. This helps me easily remember the green mixes required to paint that flower in future.

WET-ON-WET

As the name implies, this technique involves applying a diluted color over a wet region on the paper. This wet region could either be paper dampened with clean water or a different color on the paper that hasn't dried yet. When the diluted color in your brush touches this wet region, the color spreads on the paper to give soft edges and gently mixes with the other color, if there is any. This technique works great when you want to show a gentle blending of colors within a petal, for example, without forming hard edges.

WET-ON-DRY

This technique involves laying a layer of diluted color directly over dry paper or a region of the painting that has already dried. Unlike wet-on-wet, where the wet paper controls the amount of paint that spreads, here you have more control over the outcome. The wet-on-dry technique allows you to add highlights, depth and detail to a painting, with sharper edges and well-defined shapes.

Note: In this book, unless otherwise mentioned, all flower paintings start with a wet-on-dry technique, where the paper is fully dry when you begin painting.

These flowers were painted on wet paper, and the flowers have soft edges. This technique is especially useful to show flowers at a distance or to create interesting effects.

These flowers were painted on dry paper, and you can see that the flowers have well-defined edges and that all the details are clearly seen.

LIFTING

Sometimes you might want to remove color from the painting after it has been applied. This could be because you've added too much color in one spot, you want the white of the paper to show through the painting, or you want to create interesting effects in the painting.

When the paint is still wet on the paper, use a clean damp brush and gently pull out the paint from the paper and clean the brush with a damp cloth. Repeat the same process until you lift the color in that region.

You could also use a small piece of a damp kitchen towel instead of a brush to get a similar effect.

Observing and Interpreting What We See in Nature

Before we dive into the steps of painting flowers, let's start by going out into our gardens or into the wild to observe flowering plants. Let's look at what makes a floral painting interesting and what features you need to include to make your painting look natural and full of life.

PHASES OF A FLOWER

When you think of painting a flower, think about the different phases of the flower, right from a bud to a fully bloomed flower and until it wilts and browns and completely dries away.

Showing these different phases can make a painting look more natural. This holds true for the entire plant, not just the flowers. Painting the younger and older leaves and the thicker and thinner stems will also add a lot of interest in the painting.

In this example of ragwort flowers, adding buds and semi-bloomed flowers along with the fully bloomed ones makes this painting look natural. Similarly, showing the leaves at different stages, with the older, thicker leaves at the bottom and the younger, smaller leaves on top adds an element of interest.

WHAT ARE THE DISTINCTIVE FEATURES OF THIS PLANT?

Once you have chosen the flowers you want to paint, start listing at least three or four distinctive characteristics of that plant, and observe what sets it apart from other plants.

This could be the color of the flowers, the way the leaves are shaped, the thorns on the stems, the overall shape of the flowers or the way the plant dances in the wind.

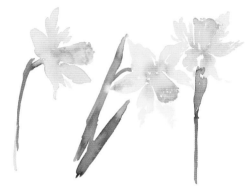

The gentle tubular protrusions in the middle of the petals are a very distinctive feature of daffodils.

The leaves of lungwort flowers have white spots all over them, and the flowers turn from pink to a lovely purple.

Mallow flowers have prominent deep pink or purple veins running from the center of the flowers, and the leaves are round or kidney shaped. These make them very easy to identify.

With just a few minimal brushstrokes, you can show what flower you are trying to portray when you focus on these main features. This will immediately help the viewer recognize the flower without being distracted by every little detail of the plant.

Exercise: Next time you go for a walk, observe a flowering plant and note three features that you find interesting about it. Try focusing only on those three characteristics when you paint and see how it simplifies your painting process.

LEARNING TO SEE IN SHAPES

Flowers, although they look fun and simple to paint at first glance, can easily become overwhelming. Once you sit down to paint flowers, either from a photo or from your garden, you start observing how intricate and complex they are. You are easily swamped by all the details in every petal, in every leaf vein, and you might begin to try to include every little detail into the painting. This may be helpful for someone intending to show a detailed botanical study of the plant, but when you want to paint loose, expressive flowers, adding too many details can make the painting look unnatural and static. You might also interrupt the fluidness of your watercolor painting by overworking it.

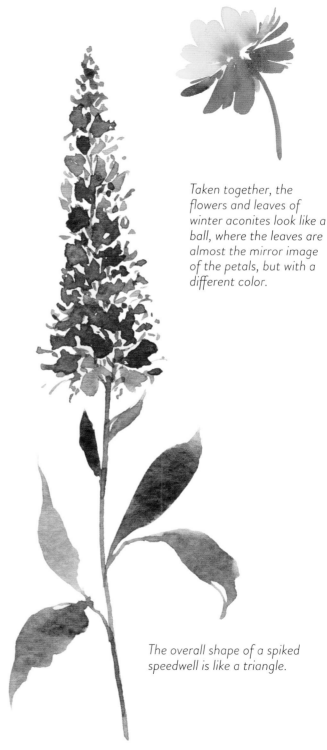

Taken together, the flowers and leaves of winter aconites look like a ball, where the leaves are almost the mirror image of the petals, but with a different color.

The overall shape of a spiked speedwell is like a triangle.

Marjoram flowers form an overall semicircular shape with one tall cluster in the middle and two shorter ones on either side.

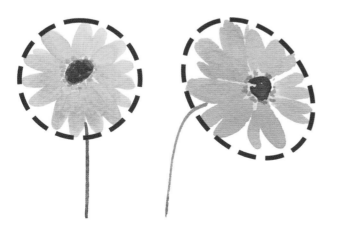

When a circular flower is facing away from you, it becomes oval in shape.

To avoid this, and to make it less overwhelming to paint flowers, start by simplifying them into basic shapes. When you see a flower, think of it as a circle, a triangle, a cylinder or a bell shape, depending on how it looks to you when you slightly close your eyes and look at it.

Once you've simplified the flower to a basic shape, observe how the shape is affected by perspective and your viewing angle.

COLORS

Now that we understand how the shape and features of a flower play an important role in painting them, let's look at how the colors affect the painting.

Observe how most flowers have several tones of the same color in them. These different tones are not only because of the natural colors of the plant, but also because of the amount of sunlight falling on them at that point in time. Even the direction of sunlight plays a role in the light and shadow play within a flower. This holds true for leaves and other parts of the plant as well.

To show strong light on one side of the plant when painting, leave white spaces that depict the brightest side, and add darker tones on the opposite side to depict the shaded, cooler area. This helps the flower look natural and full of life. Adding different tones of green within the same leaf gives the same effect. You can also depict older leaves that are about to wilt with dark tones mixed with a little bit of brown. Similarly, you can depict younger ones with a lighter tone of green.

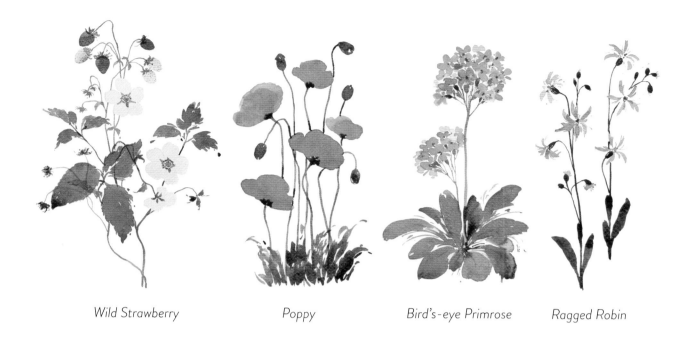

Wild Strawberry *Poppy* *Bird's-eye Primrose* *Ragged Robin*

MOVEMENT

You can create a feeling of life and movement in a painting with curving stems, drooping leaves or flowers facing in different directions. This adds a lot of interest to the composition and the painting as a whole. For example:

In the wild strawberry plant, the fruits are drooping at different angles, showing that they are heavy for the stems. The leaves and flowers are facing in different directions. The stem is windy and curved, showing that the plant is a runner and not one with a sturdy stem.

In the case of poppy plants, adding the seedpods in different angles, and the curved, long stem with the ruffled leaves at the bottom shows that the plant sways and dances in the wind.

In the painting of a bird's-eye primrose, although the flowers are tightly packed and the stems are straight, the thick leaves spilling out in different directions add a lot of movement to the painting. I have included a few random thin lines and dots between these leaves to add to their looseness.

In the case of ragged robin flowers, pointing the flowers in different directions adds to the movement of the painting.

Tip: Remember that every flower does not have to be an exact copy of the other, just like in nature. Play around with different amounts of water and brush movements to understand what you like. This greatly helps in forming your own style of painting different flowers.

Brushstrokes

The angle in which you hold the brush, the way you bend it and whether you hold it close to the tip or farther away all affect the result of your painting. Let's practice a few strokes and familiarize ourselves with the different brushes that we'll be using.

PRACTICING WITH ROUND BRUSHES

1. Start by dipping the entire brush in the paint mix on your palette until the full brush (and not just the tip) is loaded with the paint.

2. Press the brush gently, starting from the tip, and then allow the entire brush to touch the paper by increasing the pressure on the brush to get a wider stroke.

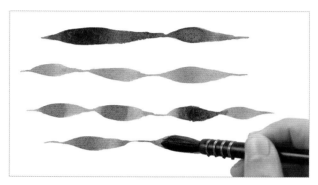

Exercise: Repeat painting thin and thick strokes until you feel comfortable with the brush. Repeat this with different sizes of round brushes to understand the potential of your brush. Then start twisting your brush in other angles to see what you can create.

PRACTICING WITH FILBERT BRUSHES

Unlike round brushes, when you turn a filbert brush around, you quickly notice that not all sides are of the same thickness. This gives us a great advantage over using a round brush in that you can get strokes of different sizes and shapes by simply turning the brush a little. For instance:

1. You can use the thicker or broader side of the brush like this.

2. Or you can use the thinner side of the brush like this.

When you practice using both the thicker and thinner sides of a filbert brush, you can create a variety of flowers, leaves and several other interesting shapes.

PAINTING LEAVES

Before diving into the different painting projects, let's practice painting a few basic leaf shapes. Painting leaves is a great way to warm up before every painting. Due to the irregular and imperfect shape of leaves, beginning with these helps to loosen our strokes and allows the hand to move freely on the paper.

In this section, we mainly focus on understanding the brushstrokes. Therefore, you can use any green color mix here for learning and practicing. (For mixing greens and choosing the right green, see Mixing Green on page 12.)

A Simple Pointed Leaf

1. Touch just the tip of the big round brush to the paper.

2. Without removing the brush from the paper, gradually press the entire brush down until it fully touches the paper.

3. Slowly move the brush away and start tilting the brush back to an upright position, until only a quarter of the brush is touching the paper.

4. Quickly pull the brush away as you lift it to get the pointed end.

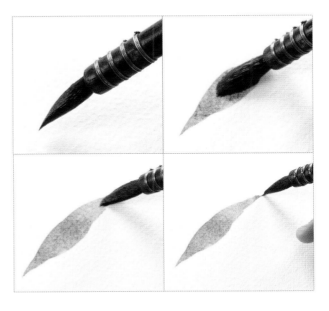

A Wavy Leaf

1. Fully press the big round brush onto the paper to get a rounded leaf. Repeat the same process right next to the previous leaf, but at a slightly slanted angle so that the base of one leaf touches the other.

2. Repeat the same process, forming an arch of leaves that are touching each other.

3. Paint another leaf right below the first leaf, but facing the opposite direction.

4. Complete the big leaf by adding more smaller leaves until all of them are touching each other.

A Round, Elongated Leaf

1. Load the entire big filbert brush with paint and press it fully on the paper.

2. Gently pull the brush diagonally downward on the paper to add length to the leaf. When you reach the end of the leaf, slightly twist the brush and quickly lift it to get a pointed end.

3. Repeat the same steps in different directions to show different angles of the leaves.

4. To change the thickness of the leaves, either use the thinner side of the filbert brush or shift to a smaller brush.

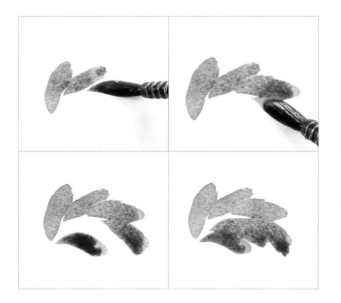

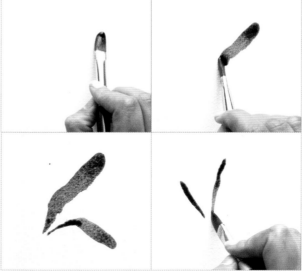

Small Oval Leaves

1. Using the thinner side of the small filbert brush, fully press the brush onto the paper to get an oval shape.

2. Add more leaves next to each other by pressing the brush slightly less each time to get smaller leaves.

3. Using a thin brush, connect all the leaves at the base with a thin line by touching only the tip of the brush to the paper.

A Thick, Ruffled Leaf

1. Paint a thick leaf by fully pressing the big round brush on the paper and pulling it upward.

2. Repeat to paint another leaf right next to it. To make this look ruffled and loose, flick your brush downward from the second leaf. This completes one leaf, with just a few minimal, quick strokes.

3. Add a few flicking strokes next to it, to make it seem wilder and more random.

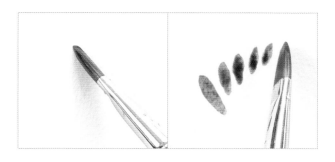

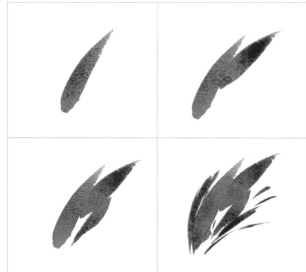

Here we painted a leaf that is drooping, but using the same technique, you can paint leaves facing different directions by simply changing the angle of every small leaf.

A Thin, Ruffled Leaf

1. Flick the small round brush sideways to get multiple thin, pointed leaves next to each other.

2. Repeat the same process diagonally to form an arch of ruffled, loose leaves touching each other.

3. Paint similar strokes below the first leaf. As you flick your brush, remember to leave white spaces in between to give it a looser look.

4. Continue painting the thin, swift strokes until all the leaves are touching each other.

5. Using the same techniques, you can paint leaves in different directions by simply changing the angle of each individual stroke.

A Circular Leaf

1. Press the entire big round brush on the paper. You can also use a big filbert brush in this case.

2. With the brush still on the paper, twist it around in a clockwise direction.

3. Just before you reach back to the starting point of this circular leaf, abruptly lift the brush to get a flat end.

4. These white spaces between the leaves depict the veins of the leaves.

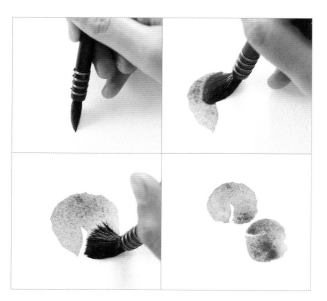

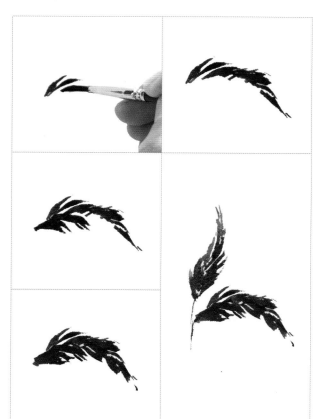

A Dandelion Leaf

1. Dandelion leaves are slightly tricky to paint due to their unique shape. To make the process simpler, start by lightly sketching a long oval shape with a watercolor pencil.

2. Take a big round brush and press it at the top of the sketch and pull it upward. Repeat on the opposite side to get an inverted V shape.

3. Paint another inverted V below, touching the previous stroke at the center so that the pointed ends on both left and right sides are visible.

4. Repeat as you go down, making sure that the spiked ends of the leaves are clearly seen. Once you reach the bottom of the leaf, fill in the rest of the region with the color, and give it a ruffled end.

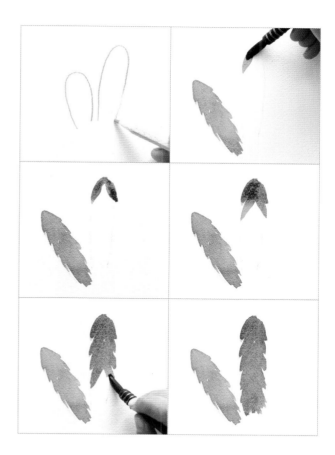

PAINTING STEMS

Hold the small round brush closer to the tip, almost like holding a pencil, and perpendicular (at a 90-degree angle) to the paper, allowing only the tip of the brush to touch the paper. Using your little finger as a support, move your wrist slowly to pull the brush in the direction you want without moving the little finger from its place. This makes it easier to paint thin, straight lines to represent the stems.

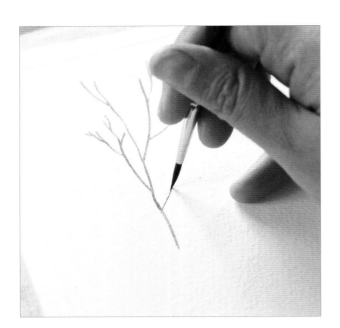

PAINTING PETALS AND FLOWERS

Let's practice a few basic floral shapes that are repeatedly referred to throughout the book. Once you understand these basic techniques, you will be prepared to paint a variety of flowers by simply varying the size, angle and color of the flowers. Once again, let's focus on learning the techniques before delving into color choice. You can use any color for learning and practicing these techniques.

Flower from Blobs

Press the big filbert brush (or even a big round brush, in this case) fully on the paper and wiggle it around as you lift it to get irregular-shaped petals. When several such petals are joined together with a thin stem, they come to life. For example, Spanish brooms and poppies are painted with similar techniques.

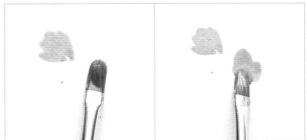

Round Petal Flower

1. Load the entire big filbert brush with the desired paint and water mix. Gently press the broader side of the brush to create a semicircular shape.

2. Repeat the same process of pressing the thicker side of the brush fully on the paper, but in different directions, all around, to create a flower.

3. To get a thin stroke, turn the brush a bit so that the thinner side of the brush touches the paper.

4. Start pulling the brush downward from the flower several times to form the tubular end of the flower.

5. You can create a variety of petals with the same technique by simply varying the size of each petal and by also switching to a round brush instead of a filbert brush. In this example, the thinner side of the filbert brush is used to paint elongated petals using the same technique.

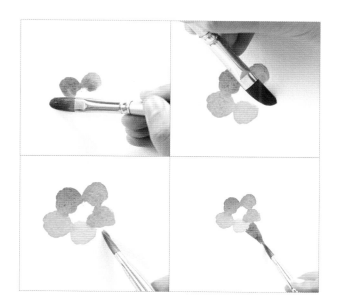

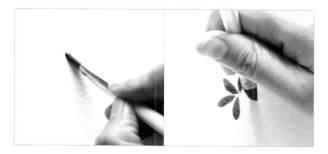

A Flower from Dots and Dashes

1. Paint little dots and dashes to represent small bunches of flowers and foliage. Hold a fully loaded small round brush at a 60-degree angle from the paper and gently touch a quarter of the brush to the paper.

Small Flower Clusters

1. Paint five petaled flowers using a small round brush, with slightly uneven petals.

2. Once the first few flowers are dry, add more such flowers, close to each other with some flowers overlapping. Vary the tone of the flowers to depict light and shadow within the cluster of flowers.

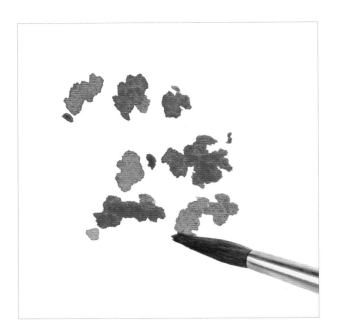

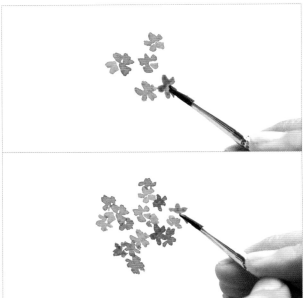

Bell-Shaped Flowers

1. Some flowers, like comfrey, are made of several bell-shaped flowers attached together. To simplify the process of painting such flowers, start by pressing a big round brush and gently pulling it downward. Give this a slightly irregular bell shape by adding another smaller stroke at the bottom.

2. Repeat, but move the brush diagonally to the right this time.

3. Add similar but smaller strokes as you go up, bending the petals slightly upward with each consecutive petal.

4. Add a few thinner strokes between these petals to give the flower a slightly wilder look. To show the drooping nature of these flowers, add a thin U-shaped stem at the top of the flowers.

5. Connect the stem to the petals with small leaflike shapes. These leaves are bigger near the bigger petal on the left, and as you move toward the smaller petals, they get smaller.

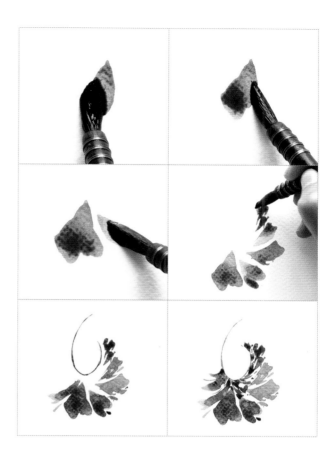

Triangular Flower

Foxglove flowers have a unique conical shape that can seem challenging to paint. To make the process easy, here are a few simple steps to help achieve the overall shape of the flower without adding too many details.

1. Paint a thick line by fully pressing the big round brush and moving it diagonally upward.

2. Lift the brush so that only the tip of the brush touches the paper to create a sharp point at the end. This creates a long, triangular shape.

3. Repeat the same process right next to the previous stroke to increase the size of this triangular flower.

4. To show the rounded, wider end at the bottom, press the brush fully and pull it slightly downward.

5. Once the flower is fully dry, add an uneven circular shape at the broader base of the flower, using a slightly darker color. Once this fully dries, add tiny dots with a darker color to show the inner texture of the flowers.

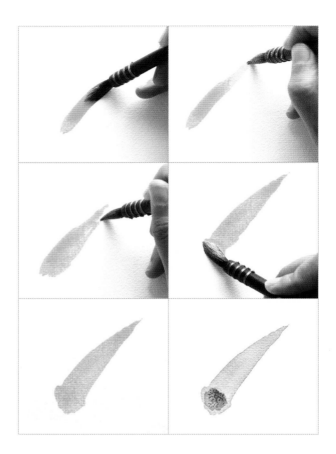

Hat-Shaped Flower

Larkspur and delphinium flowers have a slightly different shape compared to many of the wildflowers we see around. They look like a bonnet, a tall hat or a trumpet. Let's practice painting these tricky petals with a few loose strokes.

1. Paint a thick stroke by pressing the brush fully and pulling it downward at an angle to form an arch.

2. Add another stroke on the opposite side, almost like a mirror image of the previous stroke. Wiggle the brush gently as you pull it to get a slightly wider petal than the previous one.

3. Using just one-third of the brush, paint a thick, long line on the side, making sure that the line ends with a sharp tip.

4. Make this line thicker to resemble a triangular shape. Make sure that there is white space between the petals. This will represent the inner part of the flower.

5. Increase the length of the triangle so that the flower does not look stunted. Once the petals have fully dried, add a few more strokes on the right side to depict more petals and to give the flower some depth. Paint a few rough lines and dots to give it a wild look.

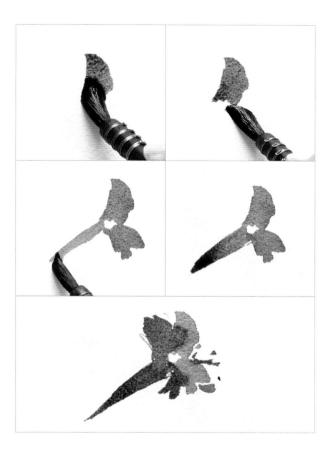

Exercise: Now that you've learned about the potential of your brushes as well as several different ways of moving the brush, you can practice the same techniques with different thicknesses of your paint-and-water mix. This will help you understand how the consistency of your paint also plays a role in controlling the ease with which you move your brush in different directions.

Wild Herbs

Since ancient times, humans have used wild plants for food as well
as treating wounds and ailments. Today, wild herbs are often used in
the kitchen to add flavor to dishes and prepare soothing herbal teas.
They have also become a part of modern medicine due
to their healing properties.

While I am not an herbalist and do not have the expertise to share
the medicinal values of wild herbs. I do enjoy painting them and
learning more about them through the process. We will be painting
a variety of well-known flowering wild herbs in this chapter,
ranging from lavenders, coneflowers and dandelions,
to chamomiles and many more.

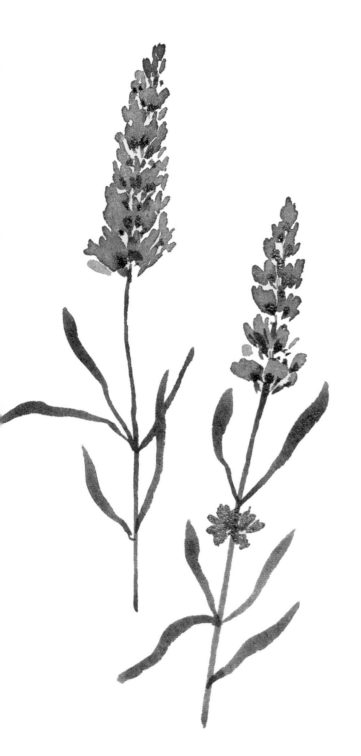

Lavender

Well known for their soothing floral scent and lovely purple color, these flowers are easy to paint with just a few simple steps. We use a small filbert brush to get the elongated shapes of the petals and build a flower, and then we add long, rounded leaves at the bottom.

COLOR PALETTE

Quinacridone rose
Sap green
Ultramarine blue

BRUSHES

Small filbert brush
Size 2 round brush
Size 4 round brush

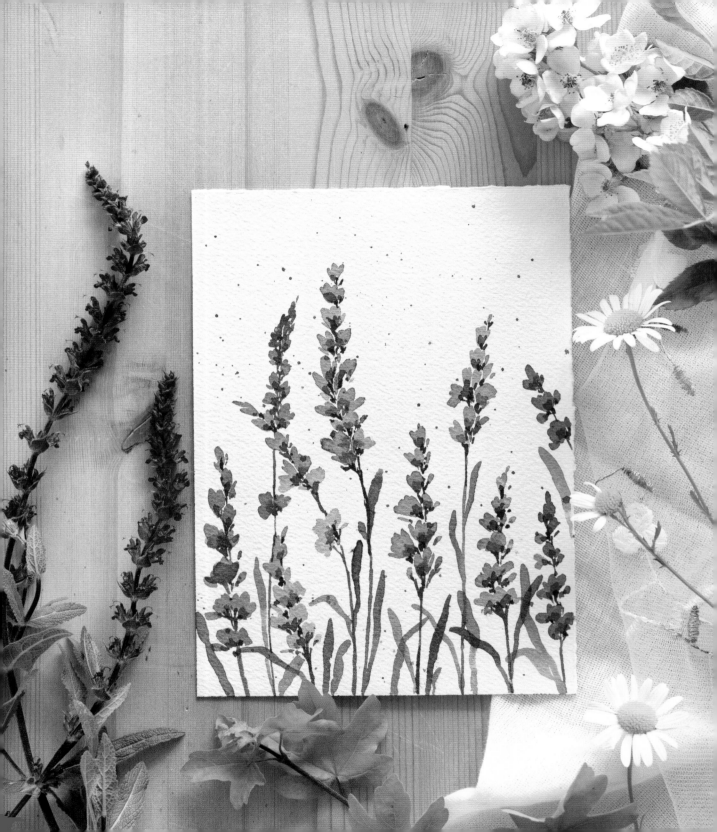

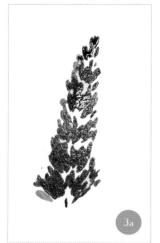

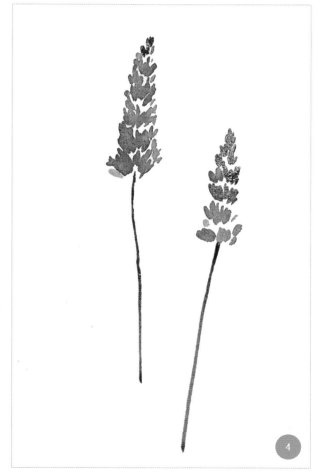

1. Mix 2 parts ultramarine blue and 1 part quinacridone rose, along with a little water to get a creamy, deep purple. Using the thinner side of the small filbert brush, paint short vertical lines that touch each other.

2. As you go down, leave white spaces in between the little strokes to help separate the flowers.

3. Make the flowers slightly bigger at each step as you go down, and paint them diagonally downward on both left and right sides. Repeat to represent another flower.

4. Mix 2 parts sap green with 1 part ultramarine blue, along with lots of water for a flowy green mix for the stem and leaves. For the stems, add thin straight lines with the size 2 brush.

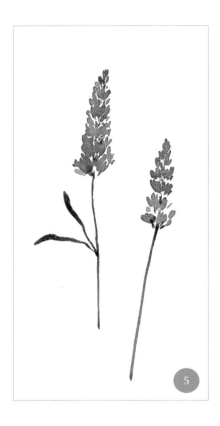

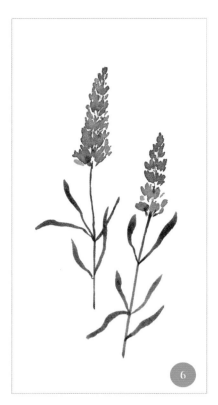

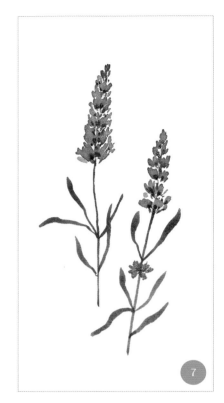

5. Once the flowers have fully dried, use the size 2 brush to add little dots of the green in the white spaces between the flowers to show that the stem is peeking through. Load the size 4 brush completely with the green mix. Press the brush gently near the stem and pull it away to show the thin, long leaves. (See A Simple Pointed Leaf on page 21.)

6. With the size 4 brush, add more leaves on both sides of the stem and in different directions. Wiggle the brush gently while it's on the paper to get slightly curved leaves. Repeat for the other flower.

7. If you desire, add a few more flowers around the stem using the small filbert brush. Take a thick paste of ultramarine blue and add little dots at the lower ends of the flowers with the size 2 brush. These highlights add depth to the painting.

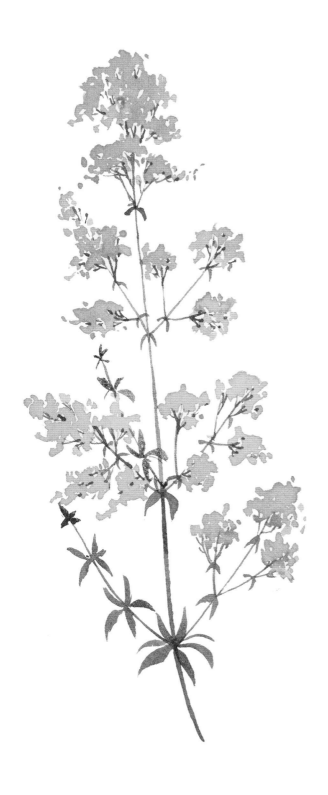

Lady's Bedstraw

The soft lady's bedstraw flowers grow in dense clusters all along the long stems, filling meadows with a gorgeous carpet of yellow. Their roots are used to prepare a lovely pinkish-red dye. It is believed that these flowers were once used to stuff straw mattresses for women about to give birth, hence the name.

We will be painting these flowers with a lot of dots and dashes to depict the fluffy clusters.

COLOR PALETTE

New gamboge
Sap green
Quinacridone deep gold

BRUSHES

Size 2 round brush
Size 4 round brush

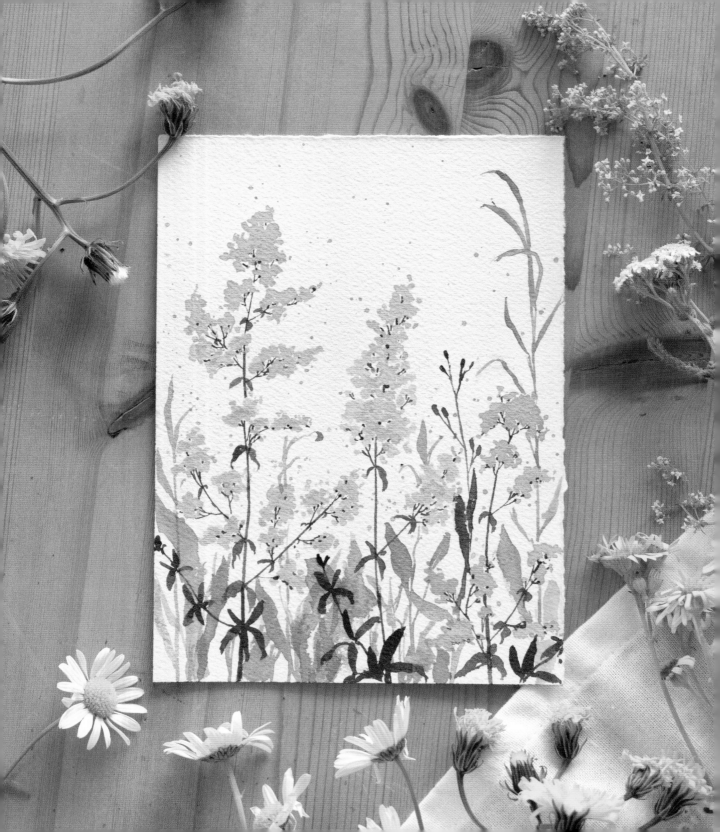

1. Using a thick paste of new gamboge, paint little dots using the tip of the size 4 brush. Allow some of these dots to merge with each other. (See A Flower from Dots and Dashes on page 28.)

2. Create smaller and bigger dots around it to give it a slightly semicircular shape. Leave white gaps in between so that it doesn't look like one big blob.

3. As you go down, make smaller clusters of these dots at different intervals.

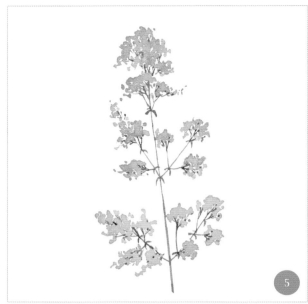

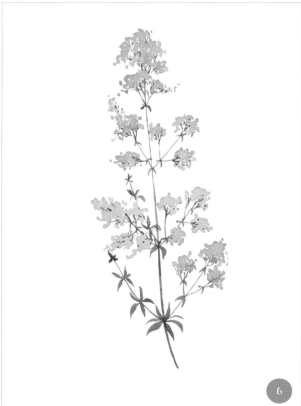

4. Prepare a thick warm green mixture of 1 part sap green and 2 parts quinacridone deep gold, along with a little water. Starting from the top, add thin lines with the size 2 brush. Join the little clusters with these strokes to make it look like a flower. Don't overdo these thin lines. You want just a few of them to show hints of the stem between the dense flowers.

5. As you go down, draw a thin, straight line using the tip of the size 2 brush to depict the main stem, and connect this to the flower clusters with thin lines. At the junctions where the stems meet, add little leaves pointing downward on both sides of the stem, using the same green mix. (See A Simple Pointed Leaf on page 21.)

6. Add similar leaves at the bottom but with thicker strokes using the size 4 brush. This shows that the leaves at the bottom are bigger and denser than the ones at the top. Paint all around the stem by moving the brush swiftly.

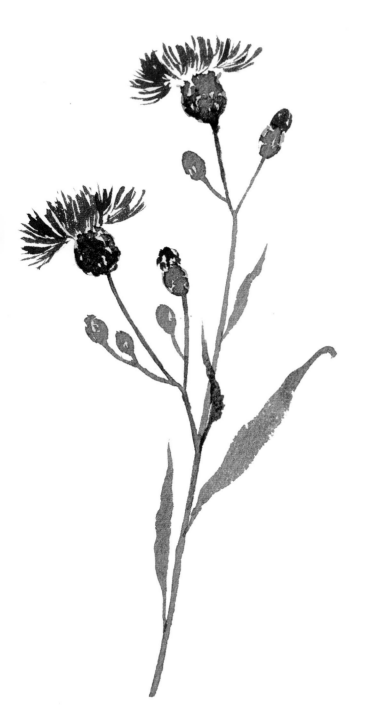

Cornflower

Cornflowers, or bachelor's buttons, are one of the most beautiful blue wildflowers. They are also easy to grow and make the landscape feel pristine in summer. Here is a quick and easy way to paint them using simple strokes and few colors.

COLOR PALETTE

Quinacridone rose
Sap green
Ultramarine blue
Quinacridone deep gold

BRUSHES

Size 4 round brush

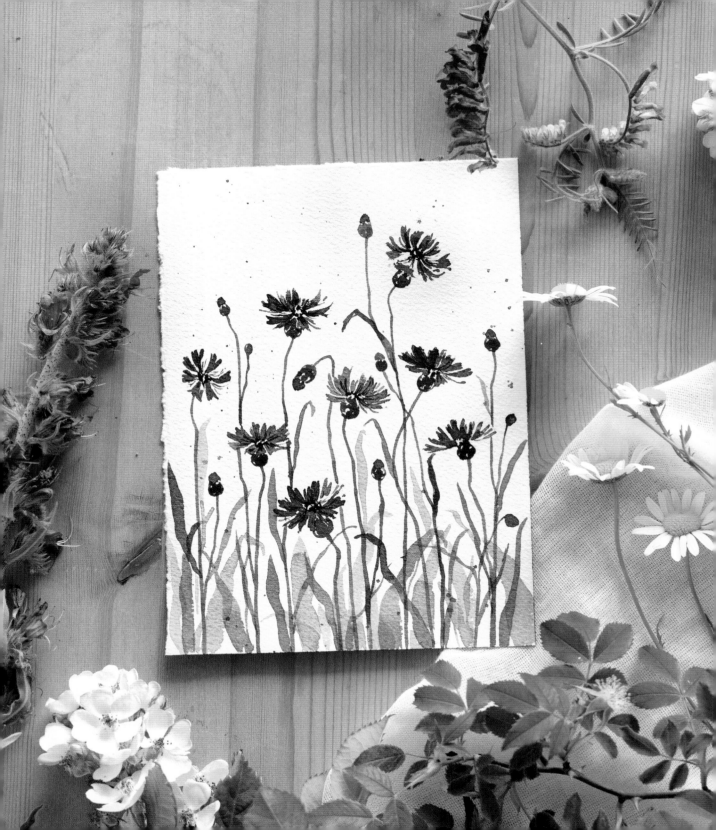

1. Mix 2 parts ultramarine blue with 1 part quinacridone rose, along with a few drops of clean water to get a creamy consistency. Depending on how big you want the flower to be, use the size 4 brush to make little upward strokes to depict both the left and right ends of the flower.

2. Fill the center of the flower with similar strokes. Add additional strokes on either side, if necessary, to make the flower look dense and wide. Repeat the above steps to create another flower.

3. While the main flowers are drying, add buds by painting little round shapes using the same color mix. Create a mix of equal parts of sap green and quinacridone deep gold. To paint the ends of the flowers, create little jug shapes at the base of both the flowers and the buds.

4. Fill these regions with the same green mix. Remember to leave white spaces in between. This naturally gives it a textured look without adding additional lines to create texture.

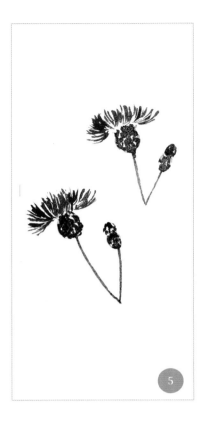

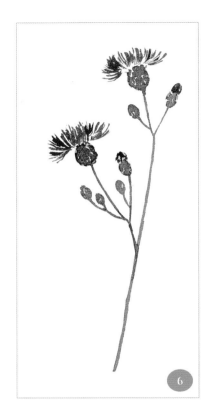

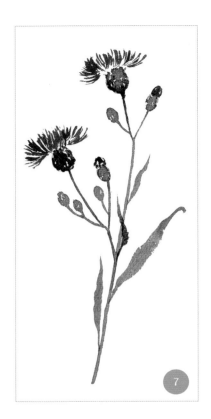

5. Connect the flowers and the bud with a thin line using the same green mix.

6. Add additional green buds closer to the flowers to make it look denser and more interesting. Connect all of them by painting a slightly thicker stem.

7. Add leaves of varying thickness by gently pressing the entire brush on the paper and swiftly pulling it upward. This helps create the pointed ends of the leaves. (See A Simple Pointed Leaf on page 21.)

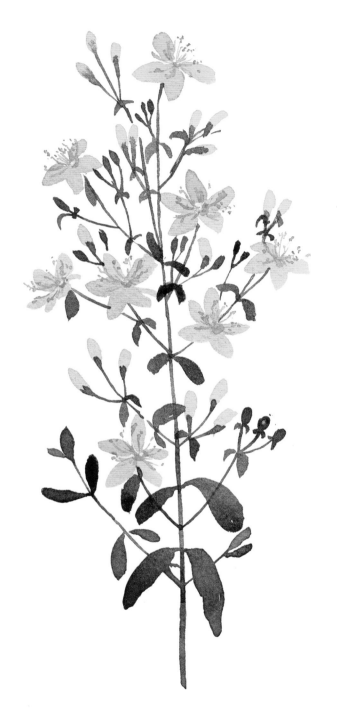

St. John's Wort

The star-shaped St. John's wort flowers are bright yellow and have immense medicinal properties. It is considered a mood-lifting herb and is called the Herb of Light. The bright-green, oblong leaves and the many hairy, bright orange stamen and pollen add character to these flowers.

COLOR PALETTE

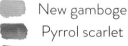

New gamboge
Pyrrol scarlet
Perylene green

BRUSHES

Small filbert brush
Size 2 round brush
Size 4 round brush

1. Mix 2 parts new gamboge with 1 part water to create a thin paste. Load the mixture on the small filbert brush and gently press onto the paper to create a petal. Repeat the same process next to the first petal, in different directions, to create a flower. (See Round Petal Flower on page 27.)

2. Add more flowers all around. Make sure that the flowers are not too crowded and have enough space between each other. Try pointing the flowers in different directions.

3. Create smaller strokes with the thinner side of the filbert brush, similar to painting the individual petals. These will represent the buds. Add as many as you want. Wait for the flowers and buds to fully dry.

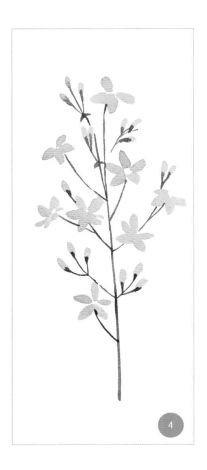
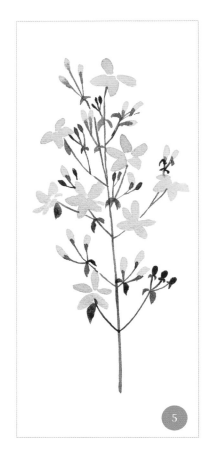
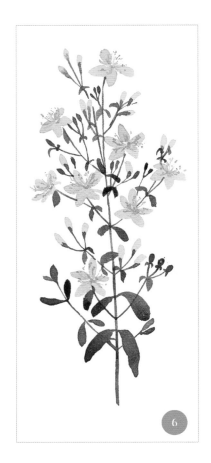

4. Mix 2 parts perylene green with 1 part new gamboge, along with a little water, for a creamy, earthy green mix. Starting from the top, almost at the center of the paper, use the size 4 brush to add a thin, long line of green to represent the main stem. Use the size 2 brush to add thin lines to connect the buds and flowers to the main stem.

5. With the size 2 brush, paint younger green buds by creating little fork-shaped lines and adding little circles at the ends. Add tiny drooping leaves where the smaller stems intersect.

6. Using the size 4 brush, add elongated leaves with round ends on the main stem. As you go down, paint the leaves bigger and longer and drooping. (See A Round, Elongated Leaf on page 22.) With the size 2 brush, use a thick mix of 2 parts new gamboge and 1 part pyrrol scarlet to paint thin lines and dots at the center of the flowers for the stamen.

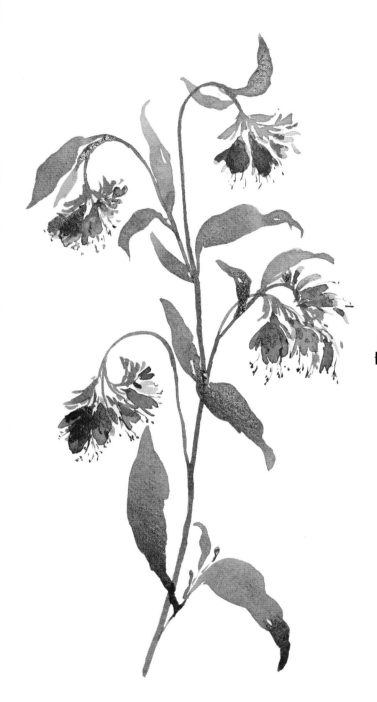

Comfrey

Comfreys are clusters of bell-shaped, pinkish-purple flowers often found along riverbeds. An important characteristic that catches the eye is the way the flowers are drooping on different sides. To show the drooping flowers, we intentionally paint the flowers facing down, unlike other flowers. We also add long stems that curve at the top to show the extent to which these flowers droop.

COLOR PALETTE

- Quinacridone rose
- Sap green
- Ultramarine blue

BRUSHES

Small filbert brush
Size 2 round brush
Size 4 round brush
Size 8 round brush

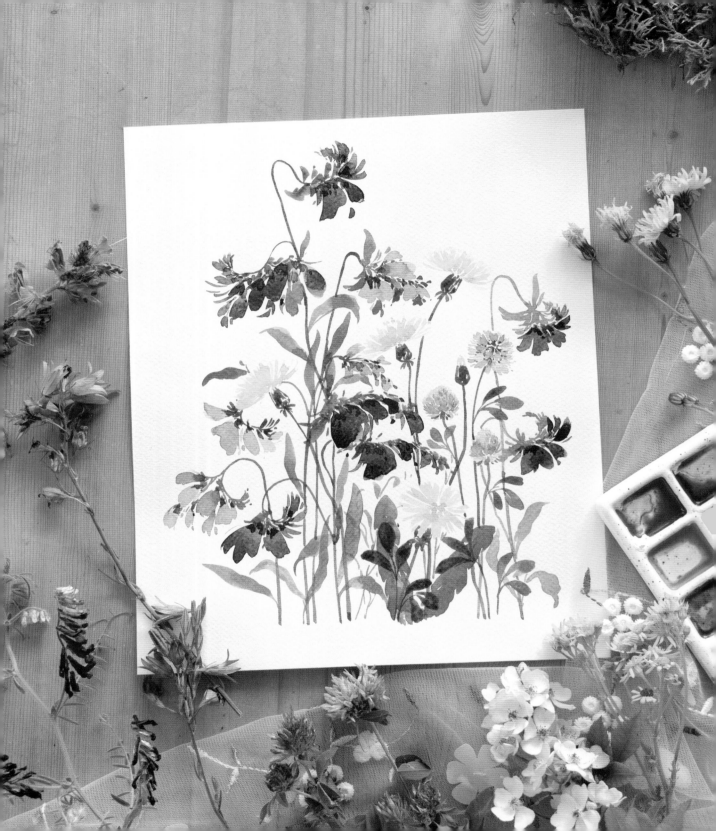

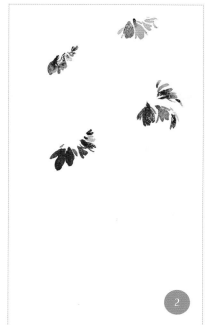

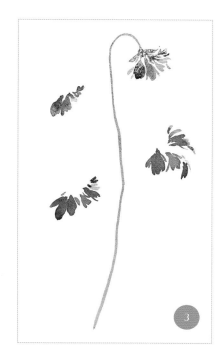

1. Mix 2 parts ultramarine blue with 1 part quinacridone rose, along with enough water to get a light purple tone. Using the small filbert brush, paint little angular strokes that grow bigger as you move downward. (See Bell-Shaped Flowers on page 29.)

2. Repeat to create different flowers. Vary the angles of each flower using smaller and larger strokes throughout. While the flowers are still wet, add a darker tone (with less water) of ultramarine blue and quinacridone rose at the tips of these petals with the size 2 brush. Allow the colors to gently blend in.

3. Prepare a darker green mixture of 3 parts sap green and 1 part quinacridone rose. With the size 4 brush, connect the clusters of flowers with thin lines. Add little leaves at the end of the flowers. With the size 4 brush, paint a curved line going downward to depict the main stem.

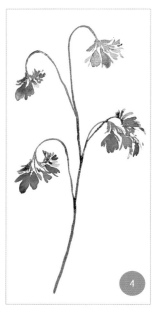

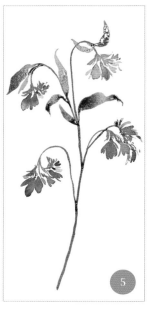

4. Connect all the flowers to the main stem using curved lines with the size 4 brush, to show that the flowers are drooping. Add little leaves at the ends of the flowers.

5. To add the big leaves, use the size 8 brush. Add slightly more water to the same green mixture until the brush moves with ease, and paint thin, long leaves at different angles to show that they are swaying in the wind. Add dabs of a darker green within the leaves to show different tones of green within them. (See A Simple Pointed Leaf on page 21.)

6. As you go down, make the leaves bigger. Mix 2 parts ultramarine blue and 1 part quinacridone rose, along with less water to get a slightly darker purple. Once the flowers are fully dry, paint over them with thin lines and dots for the stamen and thicker parts of the flowers.

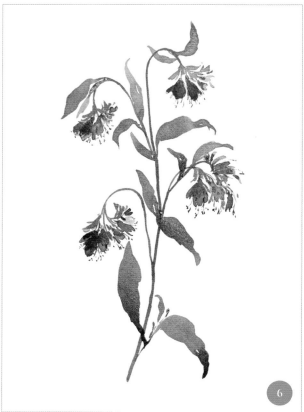

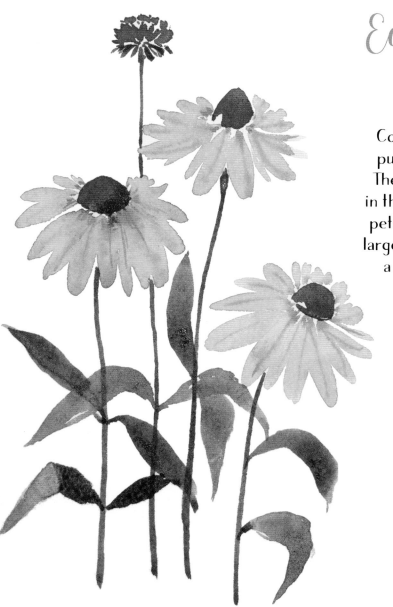

Echinacea or Purple Coneflower

Contrary to what the name suggests, purple coneflowers are mostly pink. They have large, orange-brown cones in the center and thin, long, overlapping petals that droop slightly. They grow in large numbers on long stems and attract a lot of butterflies, bees and birds.

COLOR PALETTE

Quinacridone rose
Sap green
Quinacridone deep gold
English red

BRUSHES

Small filbert brush
Big filbert brush
Size 2 round brush
Size 8 round brush

1. Mix 1 part quinacridone deep gold and 2 parts English red, along with a little water, to make a thick paste. With the small filbert brush, add a few semicircular and slightly triangular shapes at different points in different angles. These represent the cones or centers of the flowers. Add gentle little strokes at the top to show a dried flower, leaving white spaces in between to add texture. While the paper is still wet, add a darker mix of the same colors (with less water) at the lower right side of these flower heads to create a slight tonal difference. Wait for this to completely dry.

2. Mix 1 part quinacridone rose with 3 parts water for a light pink color. Load the big filbert brush completely with the pink, and using the thinner side of the brush, pull downward from the center to create petals. Starting from the left side, paint small petals and gradually increase its size as you reach the middle of the flower. As you move toward the right side, start decreasing the size of the petals. Make sure that the petals are slightly drooping.

3. Create similar petals for a second flower. This time, move the brush slightly upward while painting the petals to show that this flower is less droopy than the previous one. Using the size 2 brush and taking a thick paste of quinacridone rose with less water, draw thin lines at the center of the wet petals to create some interest in the painting. Allow these lines to slightly blend so that they don't show definite hard lines.

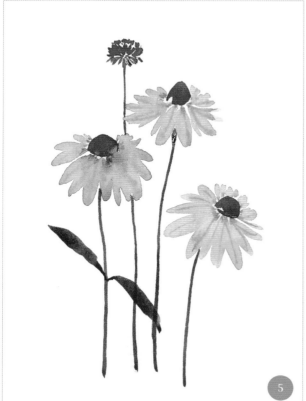

4. Another way of painting these flowers is to start by painting a few petals at regular intervals, using the thinner side of the big filbert brush. This makes it easier to get an idea of the shape of the flower you want to create. Fill in the gaps between the petals to give the flower a definite shape.

5. Once the flowers are fully dry, mix 3 parts sap green with 1 part English red, along with a little water to get a thick green. With the size 2 brush, paint long, thin lines downward from the flowers to represent stems. To paint the leaves, load the size 8 brush completely with the green mix, and starting from the stem, press the brush and gently pull it away until you get sharp ends. (See A Simple Pointed Leaf on page 21.)

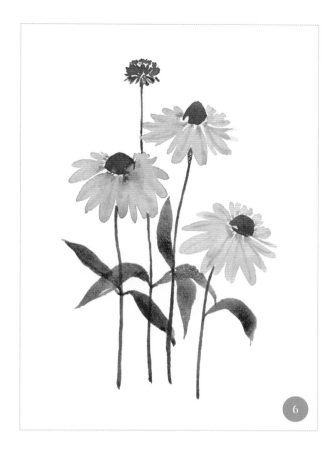

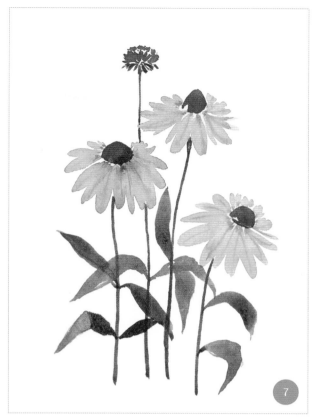

6. Create similar leaves on either side of all the stems. Make sure the leaves are at different angles, and that some of them overlap each other. You do not have to wait for every leaf to dry at this stage. Allow the colors of the different leaves to blend into each other as they overlap.

7. Add more leaves if necessary, and vary the intensity of water while doing so. This shows that light hits differently on all of these leaves, thus adding interest to the painting.

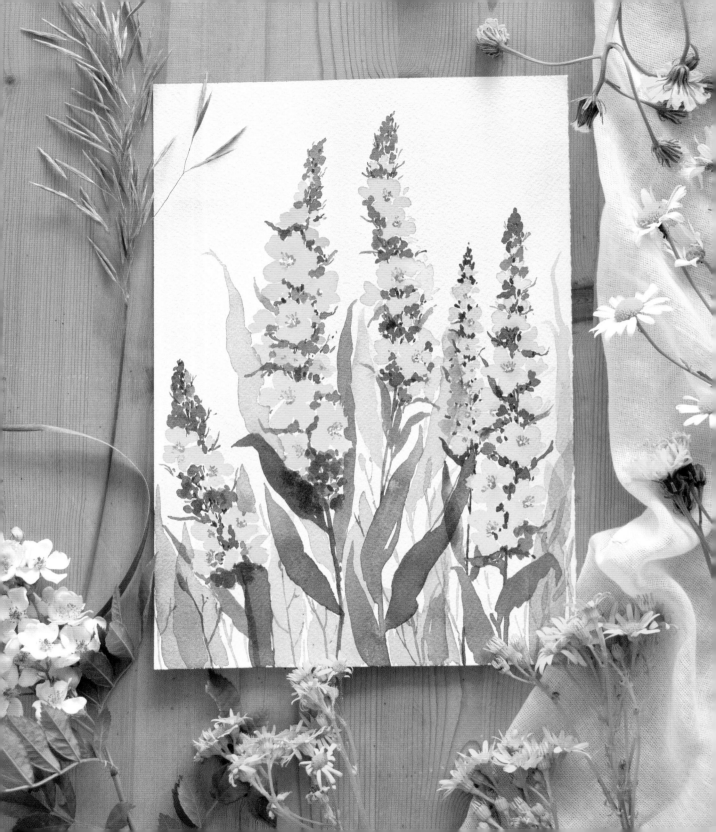

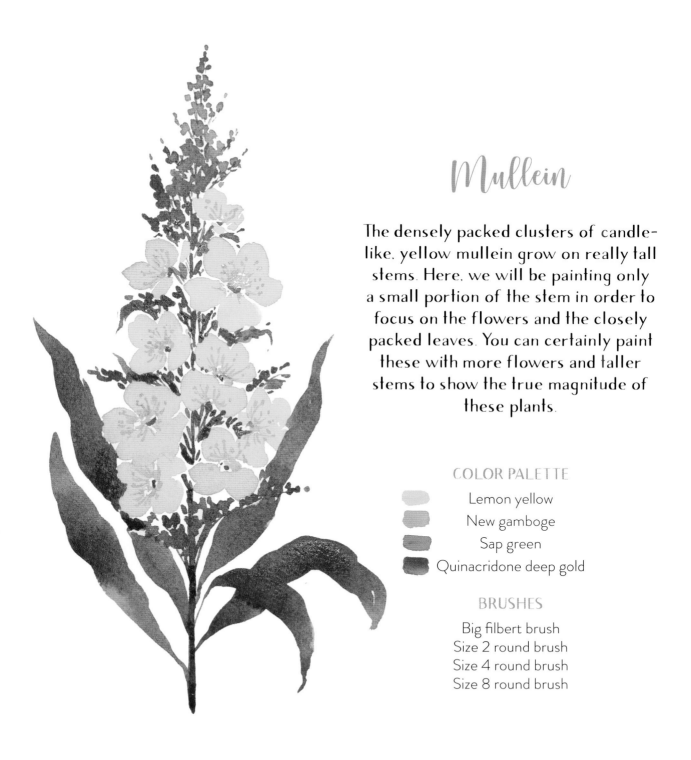

Mullein

The densely packed clusters of candle-like, yellow mullein grow on really tall stems. Here, we will be painting only a small portion of the stem in order to focus on the flowers and the closely packed leaves. You can certainly paint these with more flowers and taller stems to show the true magnitude of these plants.

COLOR PALETTE

Lemon yellow
New gamboge
Sap green
Quinacridone deep gold

BRUSHES

Big filbert brush
Size 2 round brush
Size 4 round brush
Size 8 round brush

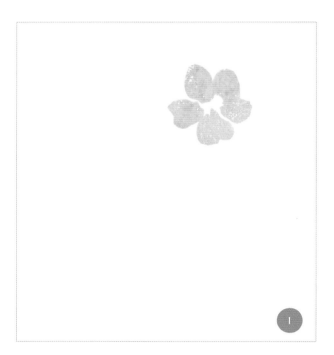

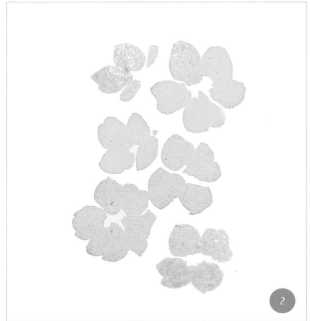

1. Mix 2 parts new gamboge and 1 part lemon yellow, along with enough water to make a watery mix. With the big filbert brush, paint petals by gently pressing the entire brush onto the paper. (See Round Petal Flower on page 27.)

2. Paint more flowers. Make sure some of the flowers are touching each other to give it a crowded look. Wait for the flowers to fully dry.

3. Mix equal parts sap green and quinacridone deep gold, along with enough water to create a lovely warm, watery green. Starting from the top, with the size 4 brush, add little dots to show the younger green part of the plant.

4. Slowly increase the size of the dots as you go down, and start branching them out on both sides. Keep these dots loose and random. Vary the amount of water in your brush to get different tones of green. Add a thin line at the center with the size 4 brush to depict the main stem.

5. Add more dots on both sides and between the flowers. Make these dots bigger as you go down.

6. Using the size 8 brush (or bigger), starting from the stem, paint long, thick leaves by pulling the brush upward. Allow these leaves to slightly touch the flowers to show that the leaves grow tightly with the flowers at the bottom. To give the leaves pointed ends, swiftly lift the brush. (See A Simple Pointed Leaf on page 21.)

7. At the bottom, add more leaves pointing in different directions and some overlapping each other. Add smaller leaves between the flowers on the top. With a thick paste (less water) of new gamboge, with the size 2 brush, add lines and dots at the center of the flowers to show the stamens.

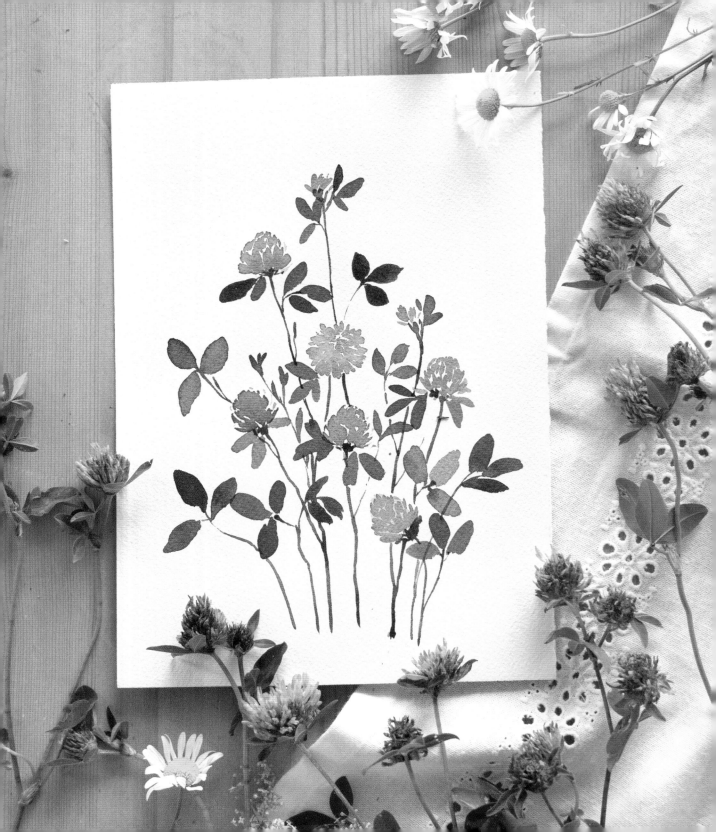

Red Clover

Clovers are nectar-rich, pink wild herbs that are a favorite of a variety of bees. These flowers are found all over pastures and meadows and are known to have immense health benefits. Clover leaves generally grow in a bunch of three, unless you are lucky enough to find a four-leaf clover! If getting the overall oval shape of these flowers seems tricky, add a very thin outline with a pink watercolor pencil first to get a sense of direction and make it easier to paint the tiny petals.

COLOR PALETTE

Yellow ochre
Quinacridone rose
Sap green

BRUSHES

Small filbert brush
Size 2 round brush

MISCELLANEOUS

Pink watercolor pencil

1. Since red clovers are not exactly red, but more on the pinkish side, we're going to mix 1 part quinacridone rose with 3 parts water to get a light pink color. With the size 2 brush, paint tiny strokes, showcasing the top of the flower.

2. As you go down, make these strokes bigger and more clustered together, but also make sure to leave white gaps in between so that it doesn't look like one big blob. The whole flower should look slightly rounded and conical at the top. To show the second flower at a different angle, paint a round flower with small strokes that slowly increase in size, keeping the white space as the center.

3. While the flowers are still wet, using a size 2 brush, add little drops of a darker tone of 1 part quinacridone rose and 2 parts water to the flowers, by gently touching the brush to the paper so that the paint spreads across and blends smoothly. This helps show different tones of pink within the flowers.

4. As we wait for the flowers to completely dry, we can paint the stem. Mix together 2 parts sap green with 1 part yellow ochre, and paint the stem with the size 2 brush. Make sure the stem is curved and bent to give it a natural look.

5. Once the flowers are fully dry, using the same green mix, fill the white spaces inside the flowers with little lines of green with the size 2 brush.

6. To add the leaves, use the small filbert brush. Gently press the thinner side of the brush to get rounded ends. Connect the leaves to the main stem with thin lines using the size 2 brush. (See A Round, Elongated Leaf on page 22.)

Dandelion

This very familiar flower, found growing on roadsides, pastures, meadows and forests, is filled with bright yellow, closely packed florets. The vibrant flowers gradually turn into beautiful, fluffy balls of seeds. I have some fond memories of blowing the parachute seeds that sail in the wind.

Dandelion leaves are unlike any of the leaves that we have painted so far. The long, toothed leaves can seem very tricky in the beginning. Practicing this a few times on a rough piece of paper can make it easier.

COLOR PALETTE

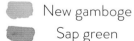 New gamboge
Sap green

BRUSHES

Size 2 round brush
Size 4 round brush

MISCELLANEOUS

Yellow watercolor pencil
Green watercolor pencil

1. Mix 2 parts new gamboge with 1 part water for a nice, juicy paste of bright yellow. Load the size 4 brush completely with the paint. Gently press the brush on the paper from the tip until the middle of the brush to get a jagged end.

2. Repeat, painting one jagged petal next to the other, to create an oval-shaped flower. If getting the oval shape seems tricky, thinly outline an oval shape with the yellow watercolor pencil, put a dot at the center of where you want the flower and paint the petals all around it.

3. Repeat for another flower. This time, point it in a different direction. Add little dots and lines in the white spaces between the petals to make it look wilder.

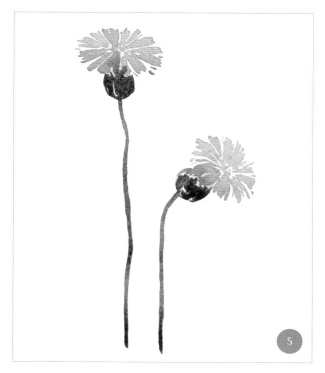

4. Once the flower has dried, mix equal parts of sap green and new gamboge to create a thick, green mix. Using the size 2 brush, create a semicircular ring under the flower. These lines don't need to be perfect, as we are going for a natural look here. Fill inside these circles using the size 4 brush, as you leave white spaces in between. These white spaces help depict texture in that region.

5. Using the size 2 brush, paint the stem by slightly pressing the brush and pulling it downward. Let the stem be slightly curved and wonky to give it a look of being bent due to the wind.

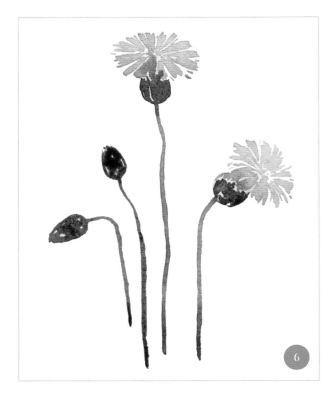

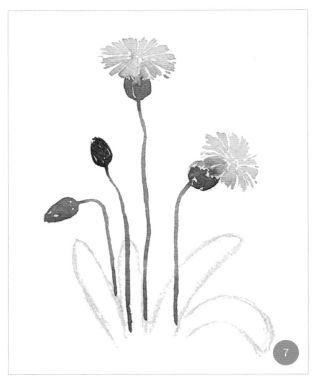

6. With the size 2 brush, outline little ovals to depict the buds. Fill them in with the same green mix using the size 4 brush, and then add the curved stems with the same brush.

7. Painting dandelion leaves can be a little challenging. Most of the time, I find it hard to get the right shape of these leaves on the first attempt. So here is a trick that makes the process slightly simpler. Using a green watercolor pencil, sketch elongated banana shapes at the bottom. This will act as a guide and will help make the painting process less intimidating. (See A Dandelion Leaf on page 25.)

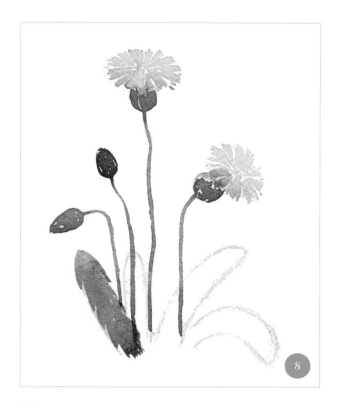

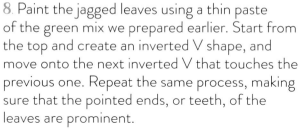

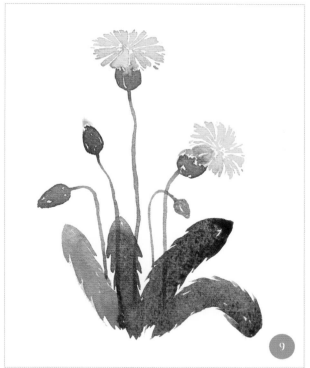

8. Paint the jagged leaves using a thin paste of the green mix we prepared earlier. Start from the top and create an inverted V shape, and move onto the next inverted V that touches the previous one. Repeat the same process, making sure that the pointed ends, or teeth, of the leaves are prominent.

9. Similarly, paint all the leaves, making sure that some leaves are big and some are small. Vary the amount of water in your brush to get different tones of green.

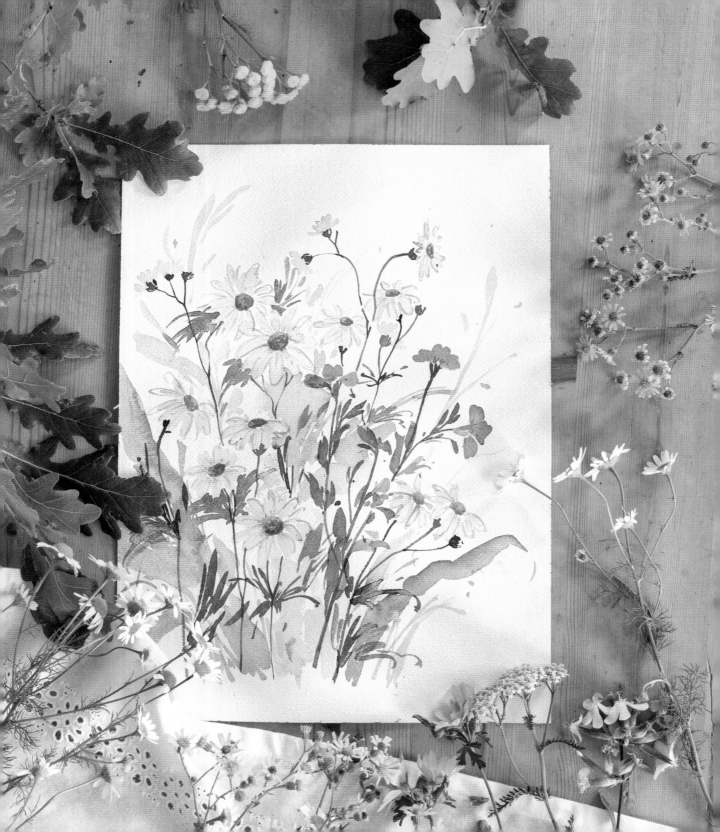

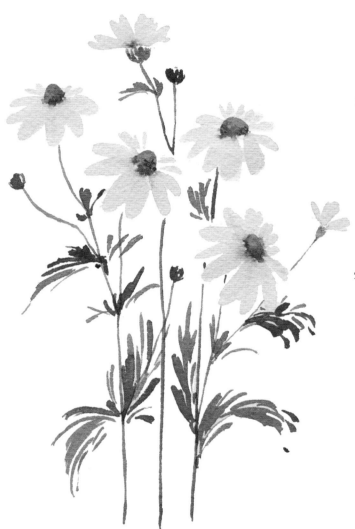

Chamomile

The pretty chamomile flowers belong to the daisy family and have such a lovely, distinct fragrance. The yellow centers and the white flowers are soothing to look at and a great addition to bouquets. Showing the white of the flowers can be difficult with watercolors. Instead of using a gray color, we will be mixing a very light brown along with a lot of water to depict white. We will also allow the yellow of the flower centers to gently spread into the petals in some places to show yellow reflections on the white flower.

COLOR PALETTE

Lemon yellow
New gamboge
Sap green
Ultramarine blue
Burnt umber

BRUSHES

Small filbert brush
Size 2 round brush

1. To make the white color for the chamomiles, you'll need very little amounts of new gamboge, ultramarine blue and burnt umber, in equal parts, along with lots of water to get a light muddy color. Test the color on a piece of paper, and if it is too dark, add more water till you get a very light, subtle color. Set this aside to use later, once the floral centers are painted.

2. Mix equal parts lemon yellow and new gamboge, along with a tiny drop of burnt umber and a little water to get a creamy mixture. With the small filbert brush, paint little ovals and semicircles to represent the flower heads.

3. While the yellow is almost dry, take the white mix, and with the help of the small filbert brush, gently pull it, starting from the head of the flower and going downward. This way, the yellow gently mixes with the white region and blends with it. Make sure that not too much of the yellow spreads into the white region.

4. Create similar strokes, one next to the other, petal by petal, until the whole flower is painted. Remember, you can change the angle of the flower by simply changing the angle in which you pull your brush to create each petal.

5. Using the size 2 brush, paint smaller, younger flowers with the same white mix. Add triangular ends at the base of these smaller flowers with a thin paste of sap green. Do this when the flowers are a little damp so that the green slightly blends with the white of the flowers. This shows that the flowers are younger and still have a green tint in them. Once the yellow centers have dried, you could go back to give it a slightly darker look in some spots using the same yellow mix as before but with lesser water.

6. While this is drying, mix the green for the stem and the leaves with 2 parts sap green and 1 part burnt umber to get a thin paste. With the size 2 brush, paint thin lines to show the stems. Add little buds here and there by painting uneven circles, and connect them to the stems using the same brush.

7. Water down the green mix to make it flow with ease. With the size 2 brush, create several leaves at different points on the stem using quick, swift motions on both sides. Make sure you leave white gaps within the leaves and also that you add the leaves at the intersections of two stems. (See A Thin, Ruffled Leaf on page 24.) Add little dots of burnt umber at the lower region of the flower heads to add texture and depth.

Tip: If you think that the yellow is too much in the petals, while the paint is still wet, gently lift the color using a clean damp brush (see page 14).

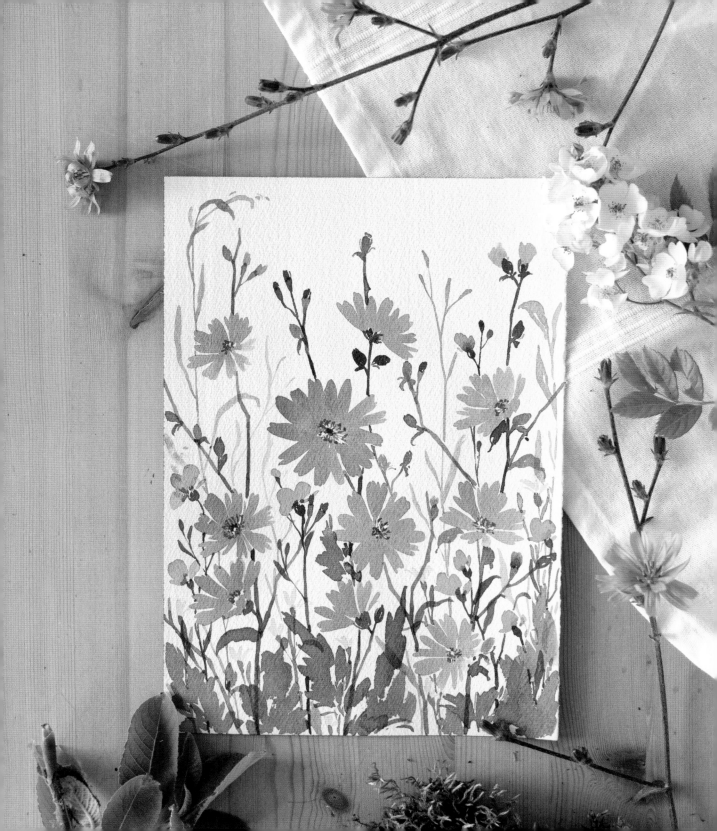

Chicory

Bright blue chicory flowers are easy to spot in meadows or along roadsides in summer. The blue makes them stand out in the midst of the many yellow and white summer wildflowers. Each chicory flower blooms only for a day. It changes color from a dark violet-blue to a lighter lavender-blue as it slowly blooms in the early morning. As the petals open fully, the color changes to a light blue, showcasing the deep blue stamen at the center. By early afternoon, when the sun is shining bright, the petals begin to close. The flowers turn into an even lighter blue, and then slowly turn white as the flower wilts away. With every new day, a new flower is ready to bloom.

COLOR PALETTE

Yellow ochre
Quinacridone rose
Sap green
Cerulean blue
Ultramarine blue

BRUSHES

Size 2 round brush
Size 4 round brush

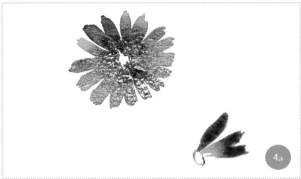

1. Mix 2 parts cerulean blue and 1 part ultramarine blue, along with enough water to get a thin paste. With the size 4 brush, paint a thin circle to depict the center of a flower. To create petals with jagged ends, start from the top of the circle, and press the brush until half of the brush touches the paper.

2. Create more petals around the circle using similar strokes, making sure that the ends of these petals are slightly toothed or jagged. Vary the amount of water and the blue as you do this to give different tones within the flower.

3. Complete the flower using similar strokes. While the paper is still wet, add little dabs of ultramarine blue around the white center with the size 2 brush so that it gently blends into the rest of the flower.

4. With the size 4 brush, paint another flower, but this time create a slight oval shape instead of a circle to show a flower at a different angle. Make sure that one side of the center has shorter petals and the other side has longer ones. This shows that you are viewing the flower at a different angle.

5a

5b

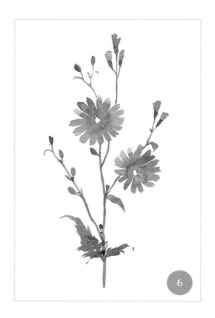

6

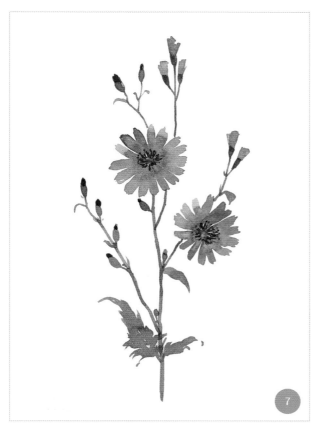

7

5. With the size 4 brush, add younger flowers by painting little inverted triangles with jagged ends. Wait for the flowers and buds to fully dry. Create a mix of equal parts sap green and yellow ochre, along with enough water to get a thin green mix. Paint a long, thin main stem, and connect the flowers together to this main stem.

6. To depict the buds, with the size 4 brush and the same green mix, add little bulbs along the ends of the smaller stems. With the size 4 brush, add rough leaves by swiftly moving the brush away from the stem. (See A Thick, Ruffled Leaf on page 23.) Add smaller leaves on top where the stems intersect.

7. Prepare a thick mix of 3 parts quinacridone rose and 1 part cerulean blue to get a purplish pink. Add little dots using the size 4 brush over the green bulbs to complete painting the little buds. With the size 2 brush, take a thick paste of ultramarine blue with just a little bit of water and paint the centers of the flowers with thin lines and dots.

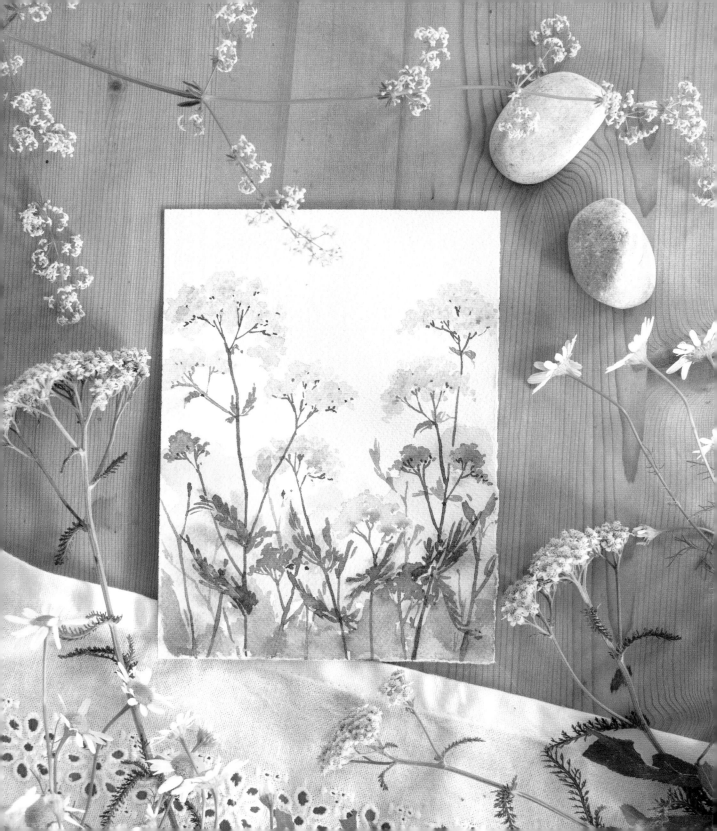

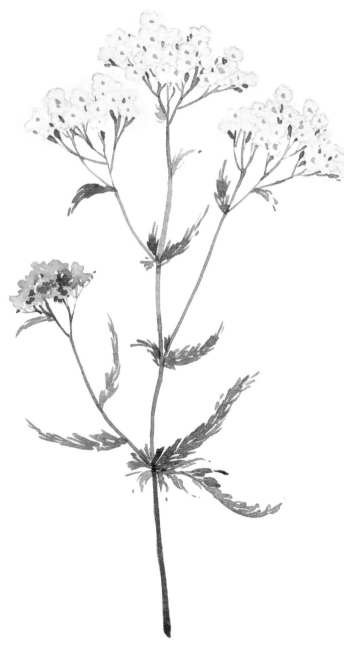

Yarrow

Wild yarrows are mostly white or pinkish white with yellow centers. They grow in large clusters on thick, long stems. Yarrows are generally identified by their distinct, feather-like leaves and their strong, sweet scent. To make the process of painting these white flowers simple, we use a gray watercolor pencil to first outline the flowers, and then we fill it with some pale colors to represent white.

COLOR PALETTE

New gamboge
Sap green

BRUSHES

Size 2 round brush
Size 4 round brush

MISCELLANEOUS

Gray watercolor pencil

1. Sketch small floral outlines with the gray watercolor pencil. Add several similar outlines that touch each other to represent clusters of flowers.

2. Add more such clusters to get an overall semicircular shape full of flowers. These floral outlines need not be perfect. They need to only represent the shape of the flower as a whole.

3. Using a clean, damp, size 2 brush, gently go over the outlines so that the colors from the pencil blend and fill into the flowers with a very light grayish color. Wait for the paper to fully dry.

4. Take a thick paste of new gamboge, and with the size 2 brush, add dots at the center of the flowers. It is important that the paper is fully dry before doing this, so that the yellow doesn't blend into the flowers and change their color.

5. Prepare a thin paste of bright green by mixing together 2 parts sap green and 1 part new gamboge. With the size 2 brush, connect the little flowers together with little V-shapes. It is not necessary to connect every flower. Focus only on the flowers at the bottom, and add only a few of these lines. Avoid adding too many of these lines and overworking the painting.

6. Add a long, thin line at the center, using the same green mix, by gently pulling the size 2 brush downward. Connect all the clusters of flowers to this main stem with thin lines.

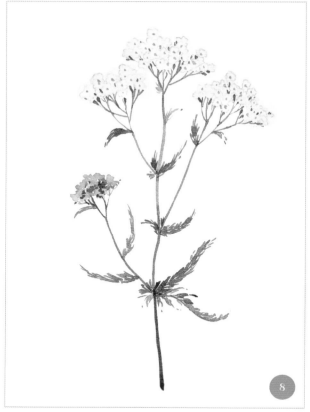

7. To show younger green buds, add 2 parts new gamboge to 1 part of the previously prepared green mix to make it brighter. Add more water to this mixture so that it flows easily from the brush. With the size 4 brush, add little dots close to each other. Vary the tone within this cluster of buds by adding slightly darker green dots here and there, and allow it to blend. Connect this to the main stem with a thin line using the size 2 brush. Add a few thin, ruffled leaves by quickly flicking the small brush.

8. The bigger leaves can be painted by stacking little rough lines next to each other using the size 4 brush. (See A Thin, Ruffled Leaf on page 24.) Try to be very spontaneous with this so that the leaves do not look too neat and perfect. Add leaves where the different stems meet and make them bigger at the bottom and smaller at the top.

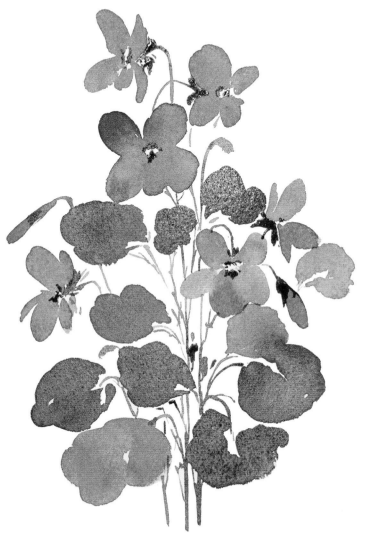

Wild Violet

Wild violets look very similar to the popular pansies and violas, but with a deep purple color. These are known to grow and adapt to any region and attract a lot of butterflies. Without adding too many details, we can portray these flowers with their distinctive shape, their slight drooping nature and the round shape of the leaves.

COLOR PALETTE

Quinacridone rose
Sap green
Ultramarine blue

BRUSHES

Big filbert brush
Size 2 round brush

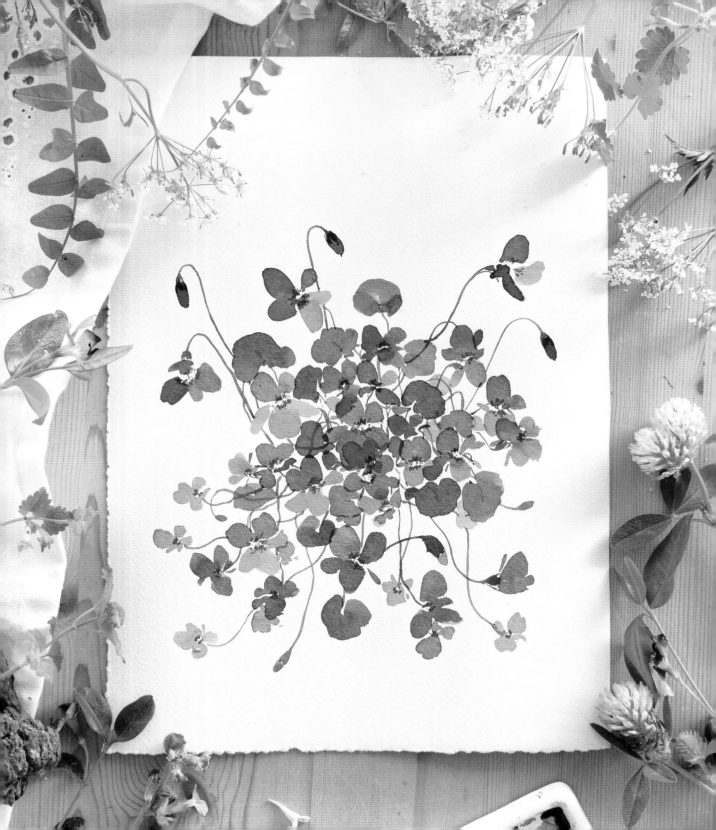

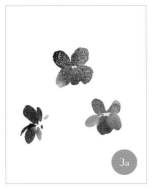

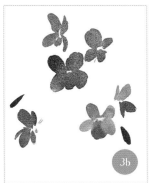

1. Mix 1 part quinacridone rose and 3 parts ultramarine blue, along with enough water to create a watery, purplish mixture. Load the big filbert brush completely and press it gently over the paper. Create semicircular shapes for the petals. Paint similar petals at the bottom to complete the flower.

2. To make it easier to get the right shape of the flower, you could start by painting two petals on top and a bigger petal at the bottom center. This helps give a sense of direction, and makes it easier to complete the flower. Paint the remaining two petals on the sides of the center petal at the bottom.

3. To paint another flower in a different angle, use the thinner side of the filbert brush and make smaller strokes. Paint more flowers using the same process, but press the brush at slightly different angles. Add little buds with the thinner side of the filbert brush. Wait for the flowers to fully dry.

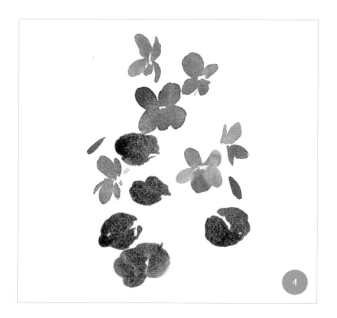

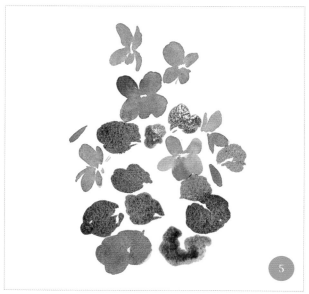

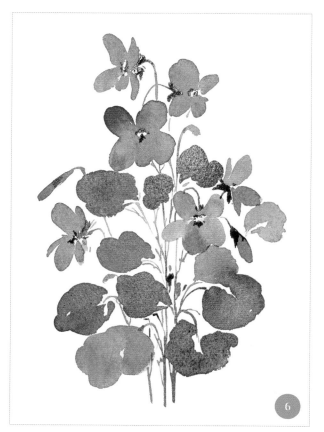

4. Mix 2 parts sap green and 1 part ultramarine blue, along with lots of water, to make a thin green mixture that flows easily. To paint the leaves, use the same filbert brush to paint a circular shape with a clockwise movement of the brush. (See A Circular Leaf on page 24.) Make sure to leave little gaps for the white of the paper to show. This depicts that there is more light falling on that region of the leaf and makes it look more natural.

5. Paint more of these circular leaves at the bottom, but in varying sizes and slightly uneven shapes, to show that the viewing angle is different for some of the leaves.

6. With the same green mixture, starting from the top, paint thin lines with the size 2 brush to create stems. Connect these to the flowers with little green ends. As you go down, add more of these stems to make it look dense. When the flowers are fully dry, use a thick mix of ultramarine to add little dots at the center of the flowers with the size 2 brush.

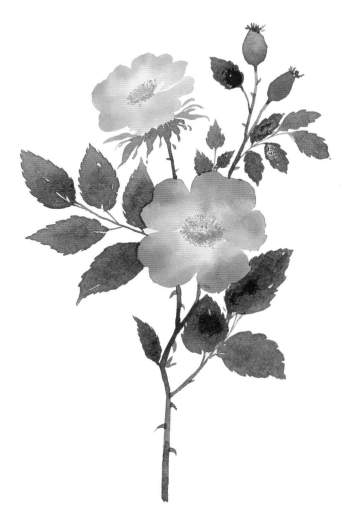

Wild Rose

Wild roses are one of my favorite flowers to spot during my morning walks in summer. I see huge bushes brimming with these sweet-scented, pink and white flowers with bees buzzing all around them. Over the few months after summer, I also enjoy seeing these gentle flowers being replaced by bright red rose hips.

Here, I have included both the flowers and the rose hips so that we can practice painting both of them. Unlike the other flowers we painted until now, to paint wild roses we will be starting with a wet-on-wet technique by first adding a layer of clean water and then adding colors to it.

COLOR PALETTE

New gamboge
Quinacridone rose
Pyrrol scarlet
Sap green
Quinacridone deep gold

BRUSHES

Big filbert brush
Size 2 round brush
Size 4 round brush
Size 8 round brush

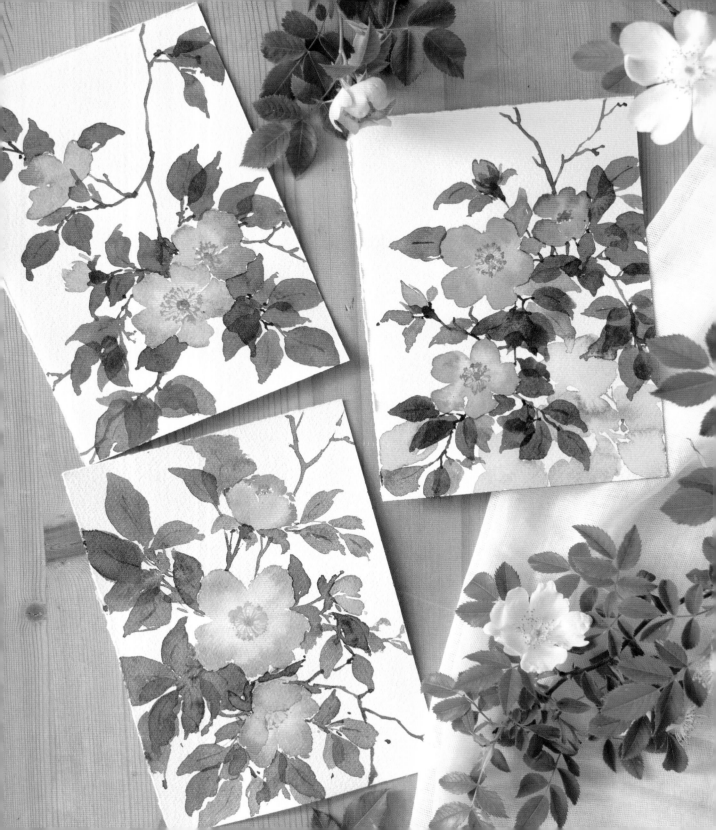

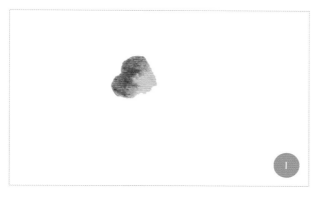

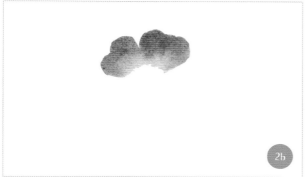

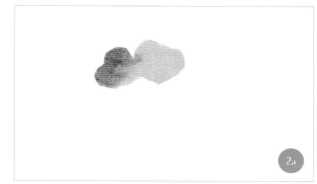

1. Take clean water in the big filbert brush, and press the brush completely to get a semicircular shape. With two such strokes, create a heart-shaped design. Mix 1 part water and 2 parts quinacridone rose, and with the size 4 brush, add this to the broader end of the wet region. Allow this to gently spread into the water on the paper. If the color is too thick and doesn't flow into the watery region, gently push it with a damp brush toward where you want the color to flow.

2. Create similar petals all around, using the same technique of first adding clean water, and then adding quinacridone rose over it at the outer ends of the petals. It might feel a little challenging to paint the right shape and make the colors gently flow in. With practice, this process becomes easier.

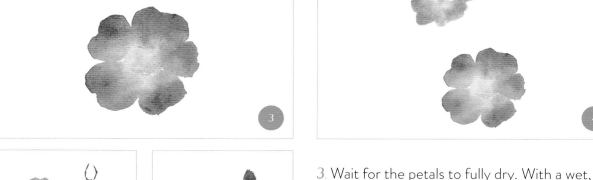

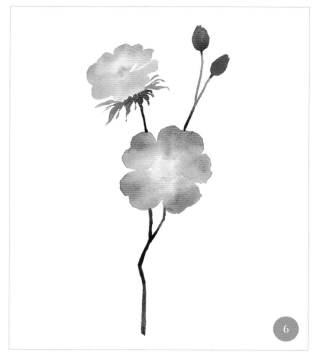

3. Wait for the petals to fully dry. With a wet, clean, size 2 brush, dampen the center white region of the flower. Make a paste with 2 parts of new gamboge and 1 part water. Gently apply this to the damp center and move it around with the brush to allow it to gently spread.

4. Create another flower. This time, paint the petals shorter to show a younger flower, and in a slightly oval shape, to show a different angle.

5. To paint rose hips, mix 2 parts pyrrol scarlet and 1 part quinacridone rose to create a thick mix. With the size 2 brush, sketch rough jug-like outlines. With the size 4 brush, fill this in with the red mix.

6. Mix equal amounts of sap green and quinacridone deep gold with a little water to get a thick, brownish, earthy green. Starting from the top, with the size 4 brush, connect the two rose hips with thin lines. With the same brush, add little leaves at the base of the younger flower on top to emphasize that it is pointing sideways. Connect it to the flower at the bottom with a thin stem. Add a slightly thicker stem at the bottom. While painting this, make sure that the stem looks sturdy by painting stiff lines with sharp ends.

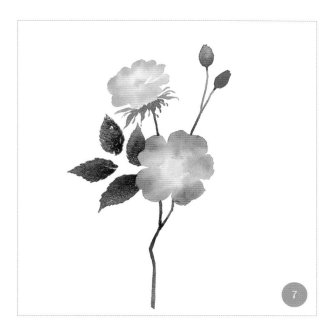

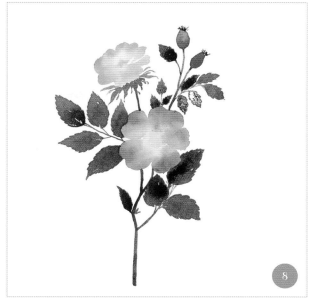

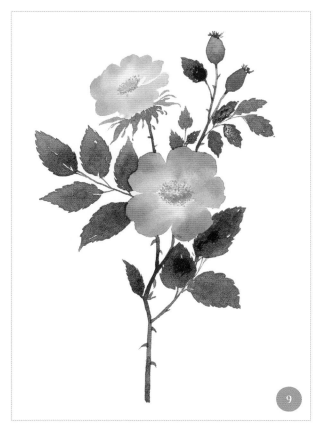

7. Add more water to the green mix to paint the leaves. Completely load the size 8 brush with the color. Fully place it on the paper and swiftly lift it. (See A Simple Pointed Leaf on page 21.) To show the sharply toothed nature of the leaves, while the leaves are still wet, add sharp, pointed protrusions on them at regular intervals with the size 2 brush. Paint similar leaves on opposite sides.

8. With the size 8 brush, paint more of these leaves around the flowers at different positions. Connect them with thin lines with the size 2 brush, and join them to the main stem.

9. Once the stem is fully dry, use the same green mix and the size 2 brush to add little crooked triangles all over to depict thorns. Mix together equal parts of pyrrol scarlet and new gamboge to get a deep orange color. Once the flower is fully dry, use the size 2 brush to add little lines and dots at the yellow centers of the flowers to show the stamen.

Wildflowers

Wildflowers are perennial beauties that not only add color to our surroundings but are also of immense ecological value. They offer the best source of nectar and pollen for a variety of insects, including bees and butterflies. A lot of local and migratory birds rely on wildflowers for their seeds.

The flowers in this chapter are chosen to help you understand painting different shapes and colors of commonly known wildflowers. Starting with simple-shaped flowers like Spanish brooms and poppies, we then move on to slightly complex-shaped flowers like cowslips, viper's bugloss and asters.

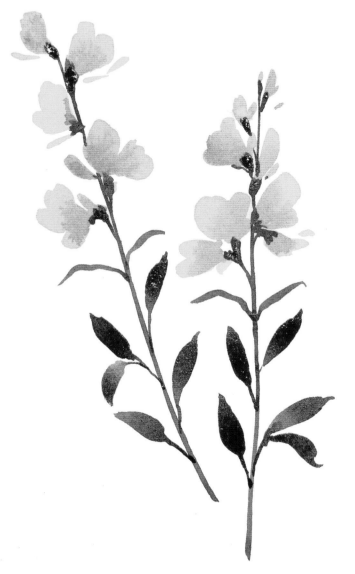

Spanish Broom

Painting bright yellow Spanish brooms is quite easy. The flowers are irregularly shaped and do not have any sharp details. The leaves are also simple and elongated and are easy to paint with a single brushstroke. If you are struggling to control your brushstrokes, painting these would be a great way to practice and have fun without putting yourself under pressure to create perfect-looking flowers.

COLOR PALETTE

New gamboge
Perylene green
Quinacridone deep gold

BRUSHES

Big filbert brush
Size 2 round brush
Size 4 round brush

1. Mix 1 part new gamboge with 3 parts water to get a thin, bright yellow paste. Load the big filbert brush and gently press it to the paper to create a petal. (See Flower from Blobs on page 26.)

2. Make bigger, irregular, heart-shaped petals as you go down. Add gentle, swift strokes with the side of the brush next to the petals to add some movement. As you go down, alternate these petals on both sides and make them bigger, combining multiple heart-shaped petals together.

3. Create another bunch of flowers using the same process. Then, create a thick golden-brown mixture of 2 parts quinacridone deep gold and 1 part new gamboge. While the flowers are still wet, add this to the tips of the petals with the size 2 brush so that the color gently blends in with the yellow. Make sure you use a small brush and a slightly thicker consistency of this color so that it doesn't blend completely with the petals and change their color entirely. Wait for the flowers to fully dry before the next step.

4. To paint the stem, use a thick paste of perylene green. Starting from the top of the flower, paint a thin straight line with the size 2 brush. Do not worry too much if you are not able to paint a perfectly straight line. Nature is full of imperfections, and your paintings can be too. Connect the flowers to the main stem. Add thick green ends at the base of these flowers while connecting them to the stem.

5. Repeat the same process for the other flower. With the size 4 brush, add the leaves. For this, add a little water to the perylene green paste to allow it to smoothly flow on the paper. Start with the thinner leaves at the top by pressing the brush fully and quickly lifting it. Increase the size of the leaves as you go down. (See A Simple Pointed Leaf on page 21.)

Indian Paintbrush

I came across these deep red Indian paintbrush flowers for the first time on a hiking trail in Grand Teton National Park. The magnificent mountains in the background, the Snake River roaring on one side, tall aspen trees on the other side, and these gorgeous red flowers carpeting the landscape . . .
what a sight it was!

COLOR PALETTE

Yellow ochre
Pyrrol scarlet
Sap green

BRUSHES

Size 2 round brush
Size 4 round brush
Size 8 round brush

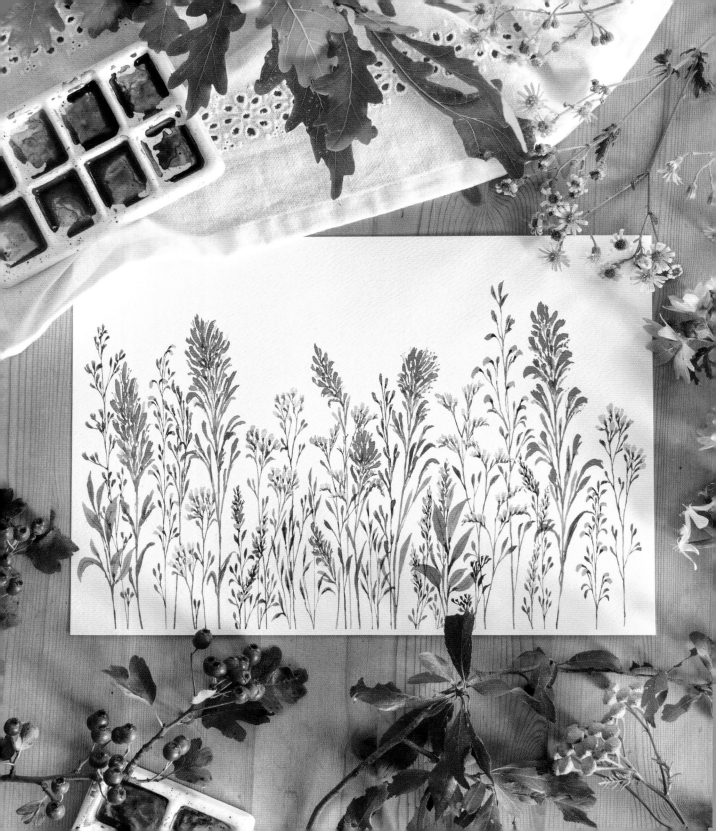

1. Mix 1 part pyrrol scarlet and 2 parts water to create a nice, watery mixture of deep red, and with the size 8 brush, paint swift long and short strokes, similar to painting leaves, to depict the upper region of the flowers. (See A Simple Pointed Leaf on page 21.)

2. As you go down, alternate on both left and right sides while painting the petals and start increasing the space between them. This is to show that the younger petals at the top are generally more crowded than the petals at the bottom.

3. To paint the stem, make a flowy green mix with 3 parts sap green and 1 part yellow ochre. Starting from the top, with the size 4 brush, connect the petals to the main stem. Do this while the flowers are slightly damp, so that the green gently blends with the red of the flowers.

4. To add the leaves, with the size 2 brush, paint swift, thin strokes on both sides of the stem. As you press the brush to the paper, slightly wiggle it to paint uneven leaves. (See A Simple Pointed Leaf on page 21.)

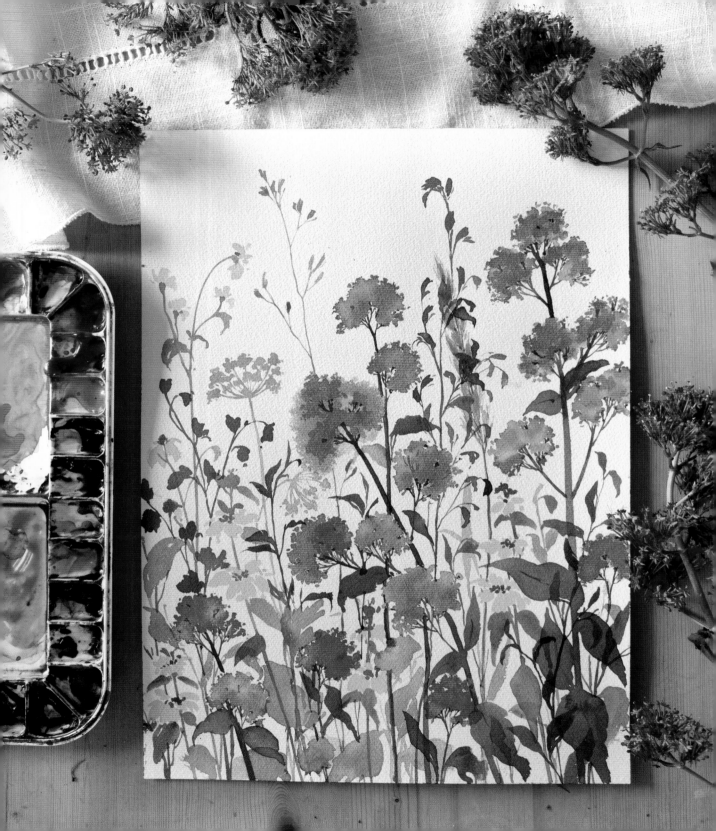

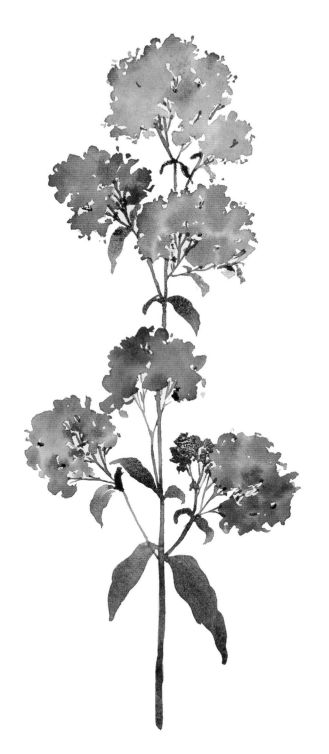

Valerian

The beautiful, deep pink valerian blooms can be seen popping out of old stone walls or along roadsides, growing in clusters on tall stems. To show the different tones of pink of these flowers, varying the amount of water in our paint mix becomes important. We start with more water to get a light pink, and then slowly add more color and reduce the amount of water to increase the intensity of the pink.

COLOR PALETTE

New gamboge
Quinacridone rose
Sap green
Ultramarine blue

BRUSHES

Size 2 round brush
Size 4 round brush
Size 8 round brush

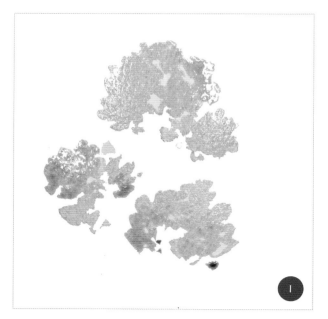

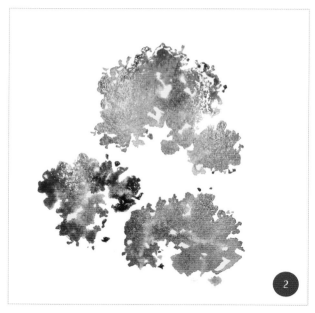

1. Mix 1 part quinacridone rose and 3 parts water for a very watered-down, light pink. With the size 8 brush, paint little dots of pink right next to each other until it forms a rough semicircle. Repeat to create more semicircular flowers.

2. Mix 1 part quinacridone rose and 2 parts water, along with a drop of new gamboge, for a slightly thicker mix. With the size 4 brush, add blobs over the wet region, and allow it to gently mix with the previous layer. Vary the amount of water in your brush to get different tones of quinacridone rose within the flower. While the paper is still wet, add little dabs of watered-down ultramarine blue in some spots to create a slight purplish color.

3. Repeat for another bunch of flowers. Wait until all the flowers are fully dry before starting with the next step.

4. Mix 3 parts sap green and 1 part quinacridone rose for a slightly dark green. Take care not to add too much quinacridone rose as that would make the mixture very muddy. Add just a few drops of water to maintain a creamy consistency. With the size 2 brush, add tiny V-shaped lines of the green mix at the ends of the flowers to bring each cluster together. It is important to make sure that the flowers are fully dry at this stage because we don't want the green to blend and mix with the pink region, which would give us a muddy color.

5. With the size 4 brush, paint a thick, straight line of the same green mix to show the main stem. Connect all the clusters to the main stem with thin lines. With the same brush, add little green dots to show a cluster of buds near the flowers.

6. With the size 8 brush and the same green mixture, paint pointed leaves at the intersection of different stems. Make sure the leaves are pointing in different directions and slightly drooping. (See A Simple Pointed Leaf on page 21.)

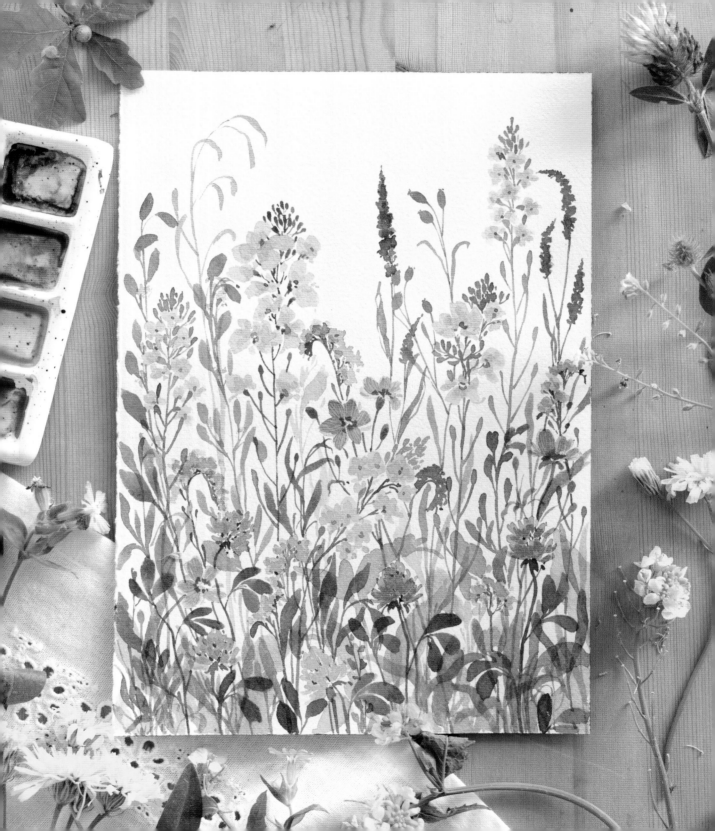

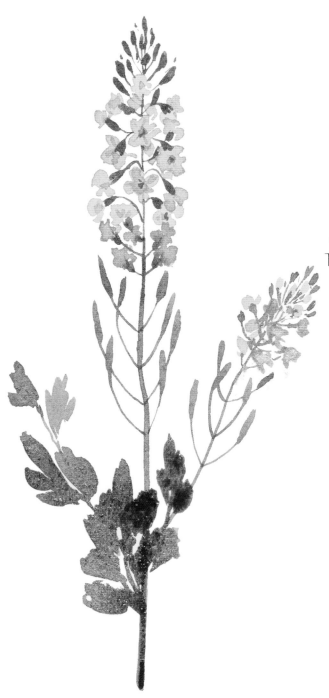

Yellow Rocket

Yellow rockets, also known as winter cress, are bright yellow flowers that grow on tall stems and add a pop of color to the landscape early in spring. They provide an early source of nectar for bees. Their seeds, which grow in long, narrow seedpods around the stem, are an attraction for a variety of birds.

COLOR PALETTE

Lemon yellow

New gamboge

Sap green

Perylene green

BRUSHES

Size 2 round brush
Size 4 round brush
Size 8 round brush

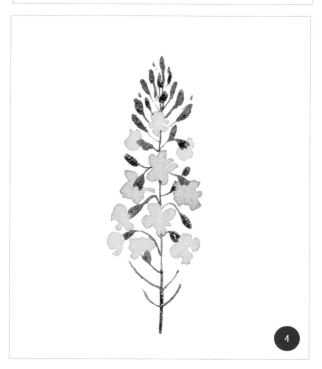

1. Mix 1 part new gamboge and 2 parts lemon yellow, along with a few drops of water, for a thick yellow paste. With the size 4 brush, create a little cluster of flowers. (See Small Flower Clusters on page 28.)

2. Increase the number of flowers as you go down, making the whole cluster look slightly cylindrical. Wait for the flowers to completely dry.

3. Create a thick green paste with equal portions of sap green and perylene green. With the size 2 brush, add short lines above the flowers to show the buds and younger parts of the plant.

4. Add a thin stem between the flowers using the size 2 brush. Join the green buds at the top to the main stem. Add little green ends for the flowers, and join them to the main stem as well.

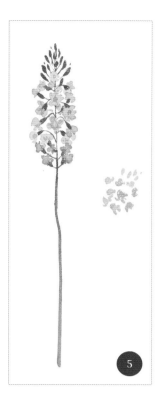

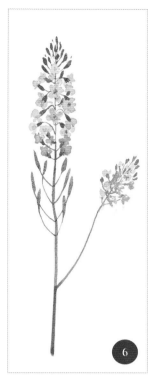

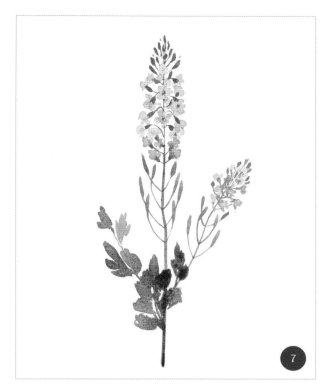

5. With the size 2 brush, use the same green mix to extend the stem with a slightly thicker line. Make the stem slightly wonky as you go down so it looks more natural. Once the flowers are fully dry, add little dots of a slightly dark tone of new gamboge (a thick paste with less water) on top of the flowers to give a slightly darker look, if you desire. Create a similar cluster of flowers on the other side of the main stem to show another bunch of flowers.

6. Add thin lines on both sides of the stem, and add thin long tubes at the end of this to depict the seedpods, with the size 2 brush. Once the flowers are dry, paint little green buds and a stem to connect the flowers to the main stem.

7. Similarly, add seedpods to the other cluster of flowers. To add the ruffled leaves, use the size 8 brush with the same green mixture but with slightly more water to make it flow easily while painting the leaves. Press the brush and move it around as you lift it to give the leaves slightly rounded ends. (See A Wavy Leaf on page 22.) Add several of these leaves to give it a slightly wilder look.

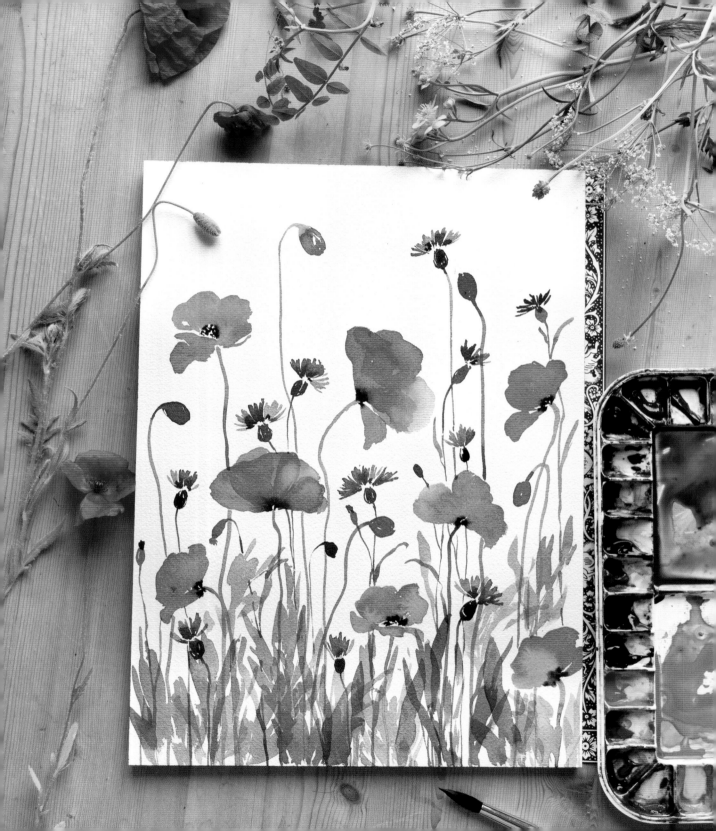

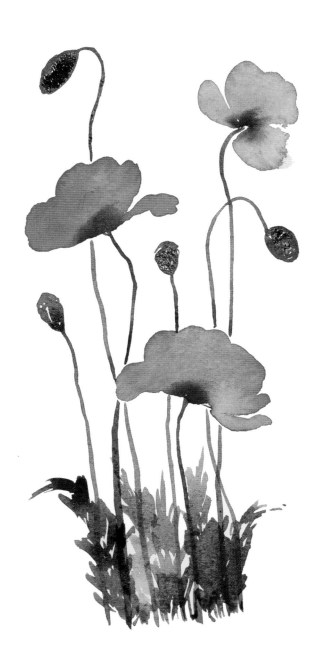

Poppy

Common poppies, with their saucer-shaped scarlet blooms, are one of the most familiar of the wildflowers. The color play of bright red poppy flowers with rich blue cornflowers and white chamomiles makes a wild meadow look absolutely fantastic.

In addition to the red flowers and dark centers, another distinctive feature that sets poppies apart are the seedpods that stand on tall stems, bending and swaying around in the wind.

COLOR PALETTE

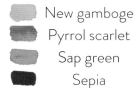

New gamboge
Pyrrol scarlet
Sap green
Sepia

BRUSHES

Big filbert brush
Size 2 round brush
Size 4 round brush
Size 8 round brush

1. Mix 3 parts pyrrol scarlet and 1 part new gamboge, along with some water to make a creamy, deep red mix. Load the big filbert brush with the paint (not just the tip, but the entire brush) and paint an uneven semicircular design (almost like a blob) by fully pressing the brush to the paper. (See Flower from Blobs on page 26.)

2. Adjust its shape using the filbert brush to make it slightly bigger so that it resembles a petal. Add another petal next to the first using the thinner end of the brush.

3. Repeat for another flower facing a different direction. These flowers can be different shapes and sizes. It is quite easy to paint poppy flowers this way because you just have to paint some blobs, and then tweak them a little!

4. Prepare a thick paste of 3 parts sepia and 1 part water. While the flowers are still wet, take the paint only at the tip of the size 2 brush, and gently touch the brush to the ends of the petals. Enjoy watching the dark brown gently spread into the red regions of the flowers. Make sure your sepia mix is not too watery, as the color would bleed too much into the red and make the flower look muddy. Create another smaller flower, if you'd like, to show the different stages of the blooming process.

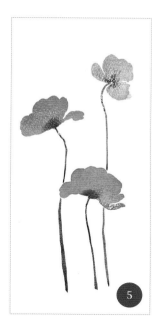

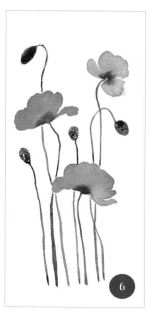

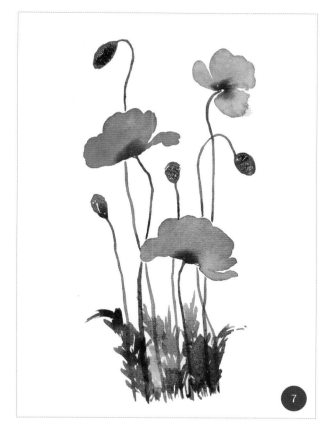

5. Prepare a dark earthy green mixture with 3 parts sap green and 1 part pyrrol scarlet, along with a little water to get a creamy consistency. To paint the stems, use the size 4 brush and add thin lines of green going downward. Make sure the stems are windy, curved and bent to show that the flowers are light and are bending due to the wind.

6. To add the buds, use the size 8 brush and create oval shapes using the same green mix. Make the stems of these buds slightly bent and curved. Add more buds of slightly different shapes.

7. Add more water to the green mix so that it flows freely from the brush. Using the size 8 brush loaded with the watery green mix, make swift, rough, upward movements from the bottom to create ruffled leaves. Repeat this to paint several leaves until the base of the stem is completely covered with leaves. (See A Thick, Ruffled Leaf on page 23.)

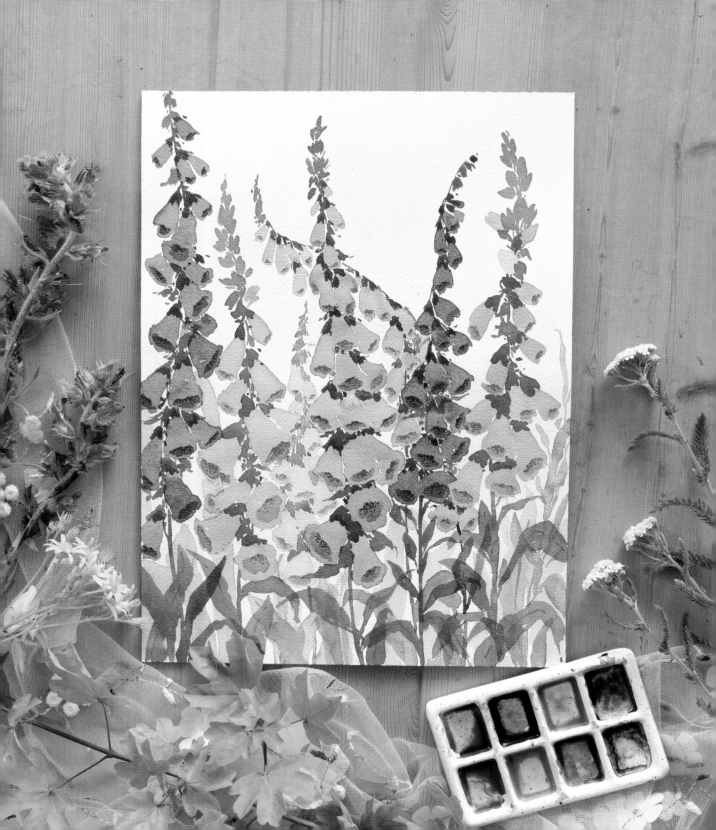

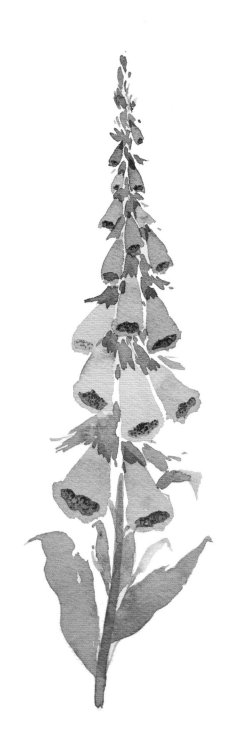

Foxglove

Foxgloves are bell-shaped flowers that grow on tall stems in a variety of purple and pink colors. Due to their tall, spike-like shape, the distinct polka-dotted interior and the poisonous nature of the flowers, foxgloves appear in several legends and folklore. It is quite fun to read about them.

COLOR PALETTE

Quinacridone rose
Sap green
Ultramarine blue
English red

BRUSHES

Size 2 round brush
Size 4 round brush
Size 8 round brush

 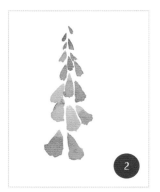 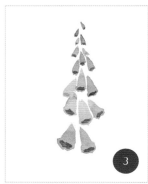

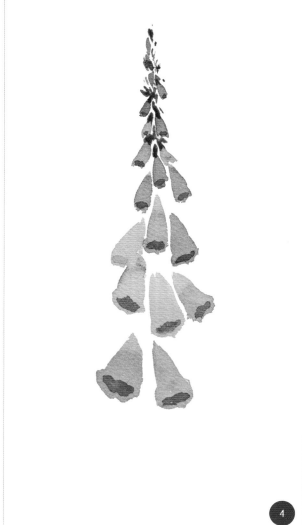

1. Mix 3 parts quinacridone rose and 1 part ultramarine blue, keeping it on the pinkish side, and add water until it's very watery. Gently touch the size 8 brush loaded with the pink color to the paper to get little triangular shapes. As you go down, make these strokes slightly bigger by pressing the brush completely to the paper and lifting it quickly to get blunt ends, creating imperfect triangles. (See Triangular Flower on page 30.)

2. Paint each flower slightly bigger as you go down, and start making the ends slightly rounded. Allow the flowers to have different tones of pink by slightly varying the amount of water in your brush while painting.

3. Prepare a thicker mixture of 3 parts quinacridone rose and 1 part ultramarine blue, along with less water than before to get a darker pink with a hint of purple. Once the flowers are fully dry, use the size 4 brush to paint uneven circular shapes at the broader ends of the flowers.

4. Create a thick green mixture of 1 part English red and 2 parts sap green, and with the size 4 brush, add little lines close to each other, starting from the top. Connect these to the flowers with uneven lines.

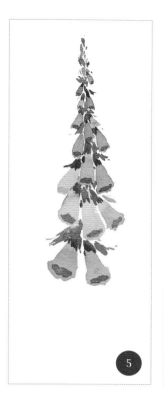

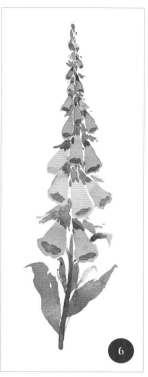

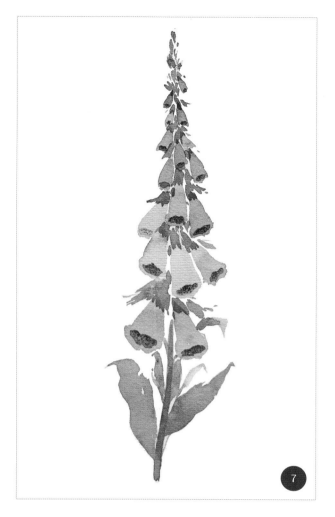

5. As you go down, with the size 4 brush, increase the size of the green lines and start adding little leaves between the flowers by quickly pulling your brush outward.

6. With the same green mixture, use the size 4 brush to add a thick, long stem at the bottom. Add ruffled, uneven leaves on both sides of the stem with the size 8 brush. This process becomes easier if you have a brush with a very pointed end. You can get the sharp ends for the leaves by swiftly lifting the brush at a 60-degree angle. (See A Thick, Ruffled Leaf on page 23.)

7. Mix 2 parts ultramarine blue and 1 part quinacridone rose, along with just a drop of water, to create a thick paste. Once the flowers are fully dry, use the size 2 brush to add little dots inside the darker pink rounded regions of the flower to show the inner texture.

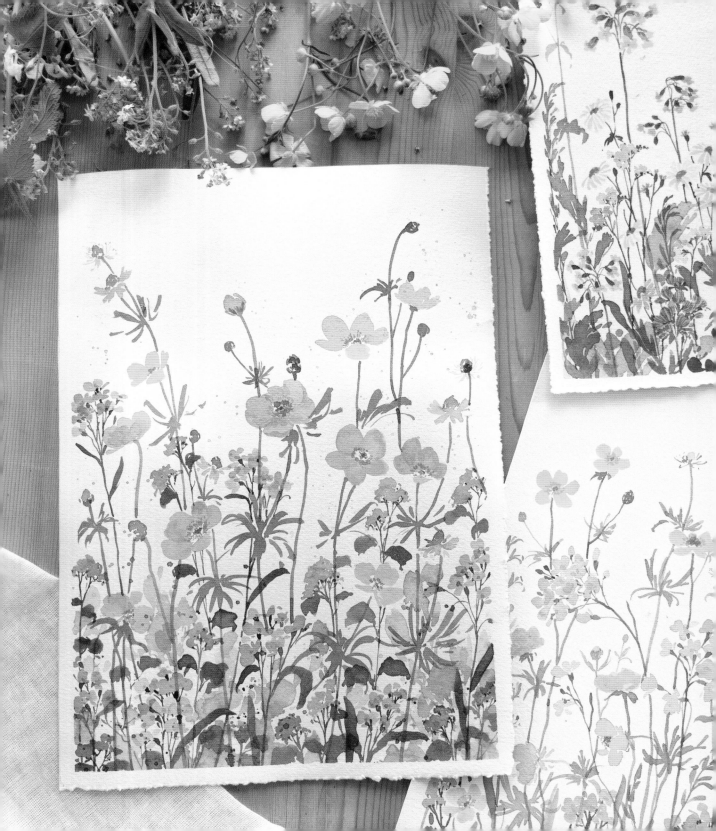

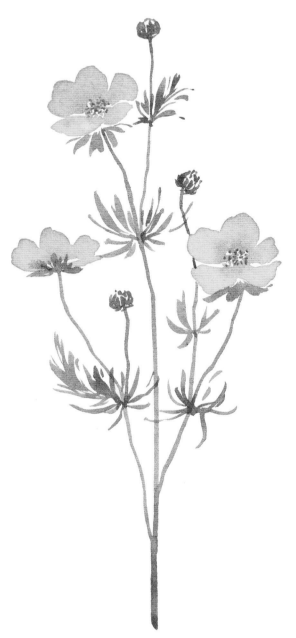

Buttercup

Buttercups are shiny, bright yellow flowers that pop up everywhere in early spring. Their petals curve inside to form a cup-shaped flower (hence the name). Due to their shape, the flowers hold a lot of sweet nectar and attract a variety of insects.

COLOR PALETTE

Lemon yellow
New gamboge
Sap green
Quinacridone deep gold

BRUSHES

Size 2 round brush
Size 4 round brush
Size 8 round brush

1. Mix 2 parts new gamboge and 1 part lemon yellow, along with lots of water. Dip the size 8 brush completely in the paint, and make a rounded stroke by pressing the entire brush on the paper and gently lifting it. Add two other petals next to it. (See Round Petal Flower on page 27.)

2. To show that the flower is pointing to the side, slightly change the way you paint the lower petals, by adding horizontal strokes.

3. Paint the other flowers using similar strokes, but at slightly different angles.

4. Mix a thick paste of 2 parts new gamboge and 1 part quinacridone deep gold. While the flowers are still slightly damp, use the size 2 brush to add drops of this mixture at the center of the flowers. Allow the paint to gently blend into the brighter yellows.

5. Mix a thin paste of green using 1 part sap green and 2 parts quinacridone deep gold. With the size 2 brush, paint little, rounded strokes to depict the buds. Make it look like the shape of a bulb, leaving white spaces in between for some texture. Make sure the flowers are fully dry, and add little, leaf-like green ends at the bottom of the flowers with the same green mix.

6. With the size 4 brush and the green mix, connect all the flowers with long, thin stems that are slightly curved and bent. Vary the amount of water in the green mix so that you get different tones of green within the stem.

7. With the size 4 brush and the green mix, paint the leaves with swift, thin strokes where different stems intersect, almost painting it like a ruffled flower. Add little dots at the center of the flowers with the size 2 brush.

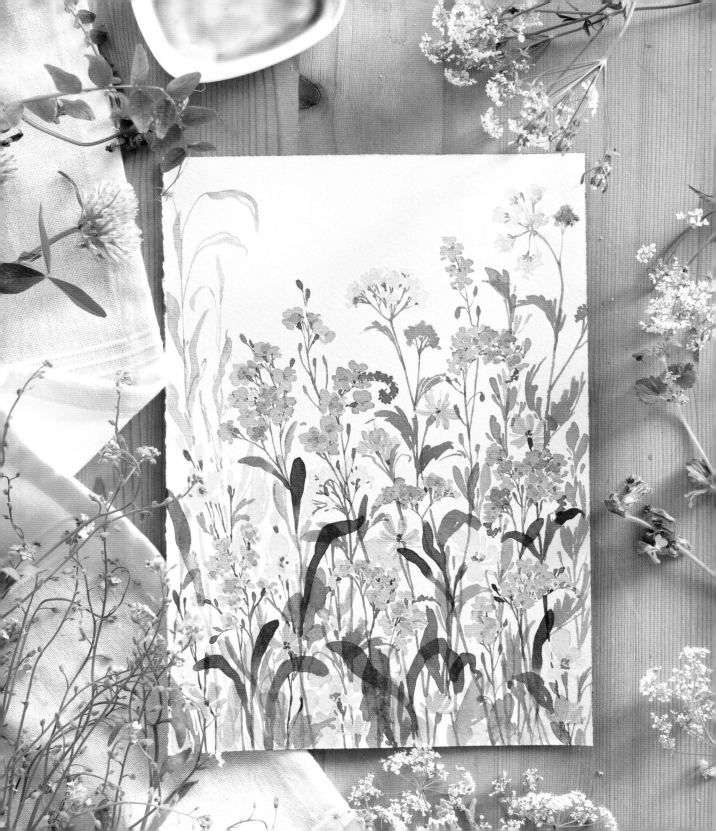

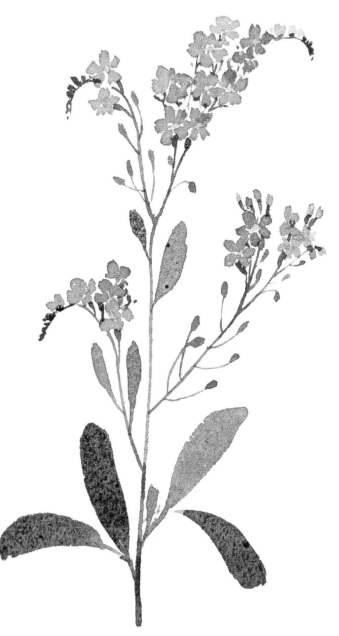

Forget-Me-Not

Forget-me-nots are tiny, delicate, blue flowers that grow in clusters. These petite flowers have small white or yellow centers, and their leaves grow in elongated oval shapes. These flowers are famously known to be a symbol of love in several countries.

COLOR PALETTE

New gamboge
Quinacridone rose
Perylene green
Cerulean blue

BRUSHES

Size 2 round brush
Size 8 round brush

1. Mix 3 parts cerulean blue and 1 part quinacridone rose, along with several drops of water, to get a slightly purplish, light blue. With the size 2 brush, paint little five-petaled flowers. Keep adding more flowers close to each other with some touching each other. (See Small Flower Clusters on page 28.)

2. To depict different clusters of flowers, add similar strokes at different spots on the paper. Add a few thin lines to show the buds. Keep varying the intensity of the blue by varying the amount of water used in the brush.

3. Once the flowers are fully dry, mix 2 parts perylene green and 1 part water to create a thick green paste. Paint thin lines with the size 2 brush that connect the cluster of flowers. Add little green buds at the ends of the flowers on top, in a slightly drooping style, to show the typical style of growth on forget-me-not flowers. Connect the other flower clusters with long, thin stems.

4. With the size 2 brush, paint thin lines along both sides of the stem with oval-shaped seedpods at the end. Point them in different angles to give them a sense of movement.

5. To paint the leaves, mix 2 parts perylene green and 1 part new gamboge, along with lots of water, for a thin, flowy green. Press the loaded size 8 brush fully on the paper, and very gently pull it to create slightly rounded ends. (See A Round, Elongated leaf on page 22.) Using the size 2 brush, with a thick paste of new gamboge, add little dots at the centers of the flowers. Make sure that the flowers are fully dry at this stage so that the yellow does not mix with the blue, which would turn the flowers green!

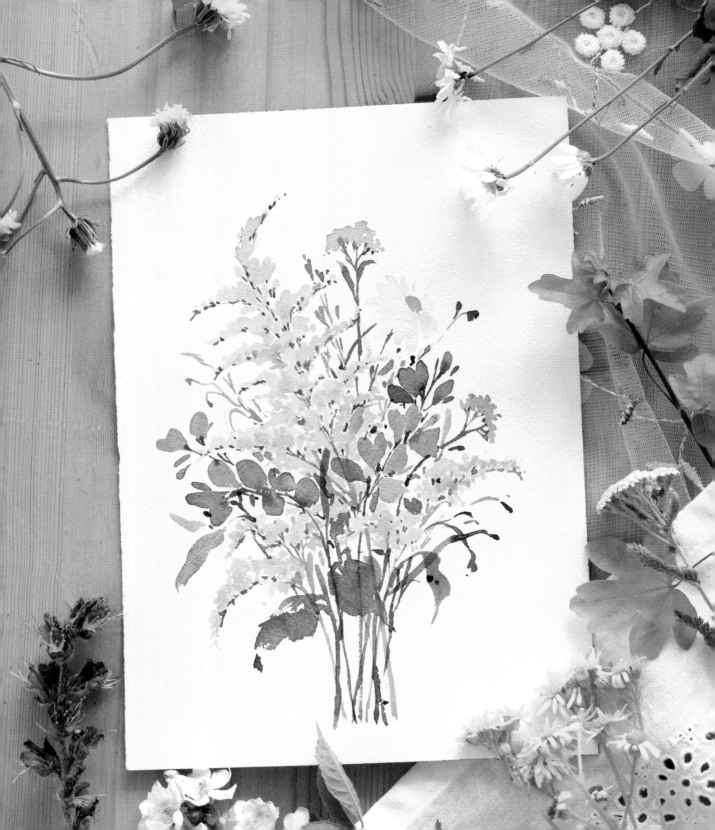

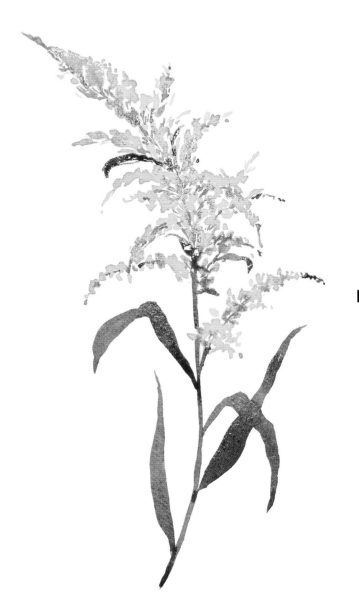

Goldenrod

Goldenrods are tall, stunning, bright yellow flowers that bloom late in summer. They are known to attract a wide variety of bees and butterflies. To depict these fluffy flowers, we use the tip of our brush to add a lot of little dots and lines close to each other, starting from the top until we reach the end of the flower.

COLOR PALETTE

New gamboge
Sap green
Quinacridone deep gold

BRUSHES

Size 2 round brush
Size 4 round brush

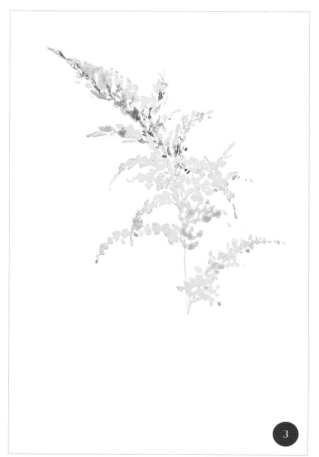

1. Mix 1 part new gamboge and 3 parts water to create a thin yellow. With the size 4 brush, paint little lines next to each other at a slight incline. (See A Flower from Dots and Dashes on page 28.)

2. As you proceed diagonally downward, make sure that the strokes are slightly thicker and start branching out on both sides with similar florets. Slowly increase the size and change the angles to add movement. Leave white spaces between them. Make sure the little dots and lines are not very orderly and look wild and natural.

3. Mix 2 parts sap green and 1 part quinacridone deep gold, along with enough water to create a thin, greenish-yellow mixture. While the flowers are still wet, use the size 2 brush to add little lines between the flowers. You do not need to add one thick visible line, rather just a few little lines to show hints of the stem in the midst of the flowers.

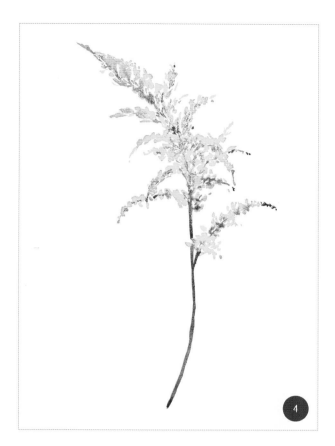

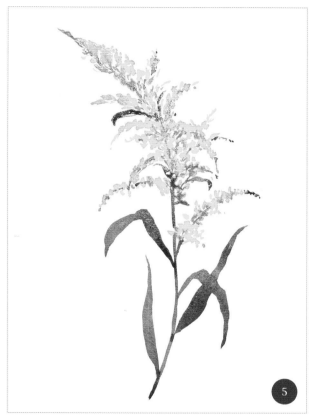

4. Allow the green to slightly blend with the yellows. As you go down, make the stem slightly thicker with the size 4 brush.

5. Use the watery green mixture with the size 4 brush to paint long, thin leaves at the bottom. For this, start from the stem, press the entire brush, gently wiggle it as you pull it away, and then quickly lift it to get the pointed ends. (See A Simple Pointed Leaf on page 21.) Once the flowers are fully dry, add little leaves between them as well.

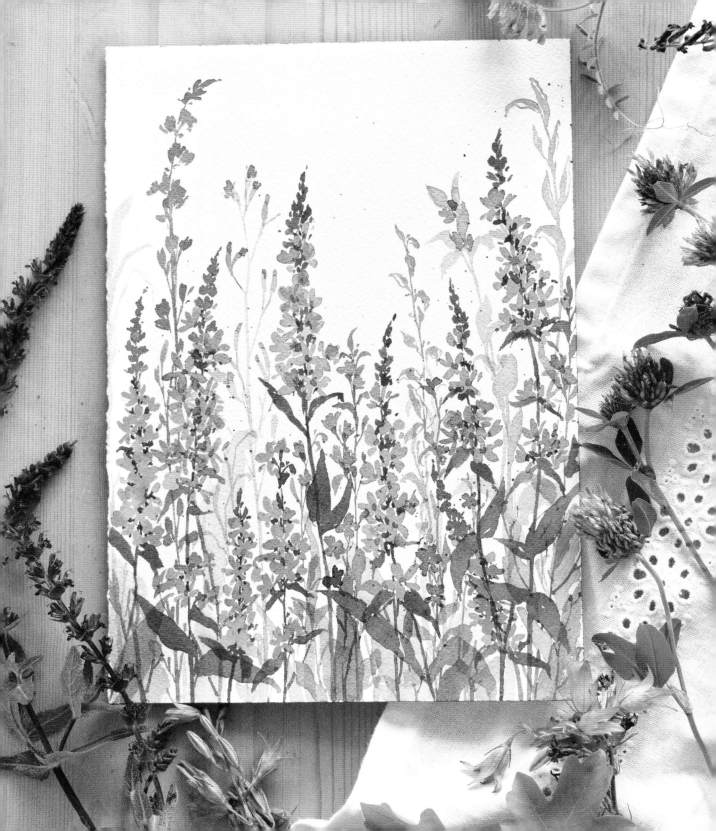

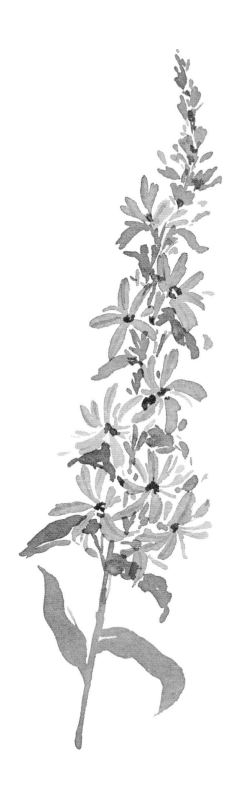

Purple Loosestrife

Purple loosestrife plants are tall with lovely pink or magenta flowers. Although highly invasive, I love seeing these flowers near riverbanks and growing between rocks here in Europe. It may seem slightly tricky to paint these due to the thick cluster of flowers and leaves—however, they can be simplified when you focus on just a few of the flowers and paint over several repeated steps.

COLOR PALETTE

Quinacridone rose

Sap green

Burnt umber

BRUSHES

Small filbert brush
Size 2 round brush
Size 4 round brush
Size 8 round brush

1. Mix 1 part quinacridone rose and 3 parts water to create a light pink. With the small filbert brush, paint little heart-shaped strokes at the top, using the thin side of the filbert brush.

2. Paint more of these heart shapes as you go down, but at different angles.

3. Paint another flower, but this time face it towards us instead of facing sideways. (See Round Petal Flower on page 27.)

4. Paint similar flowers, but in different directions to show movement. Using the thin side of the filbert brush, make sure to keep your strokes light and swift so you don't get very rigid flowers. As you go down, add flowers closer to each other to make it look denser at the bottom.

5. Mix 3 parts sap green and 1 part burnt umber, along with enough water to create a flowy green mixture. With the size 4 brush, add little dots and lines, starting from the top, to show the younger parts of the plant. Increase the size of these strokes as you go down, making sure to leave white spaces in between.

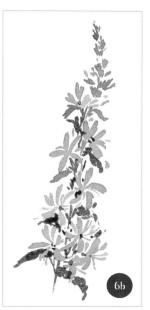

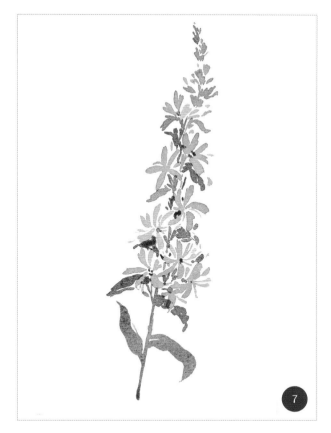

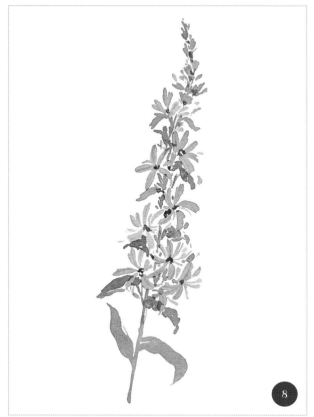

6. Paint little leaves between the flowers with the size 4 brush. Make sure that these leaves are not too perfect and droop slightly downward.

7. Add the main stem by drawing a long, thick line at the bottom, and add leaves on both sides with the size 8 brush. Make sure that these leaves are pointing in different directions to make the plant look more natural. (See A Simple Pointed Leaf on page 21.)

8. Once the flowers are fully dry, take a thick paste of quinacridone rose onto the size 2 brush, and add little dots at the center of the flowers. Add a few drops of water to the quinacridone rose to make it slightly lighter, and add thin lines on some of the petals.

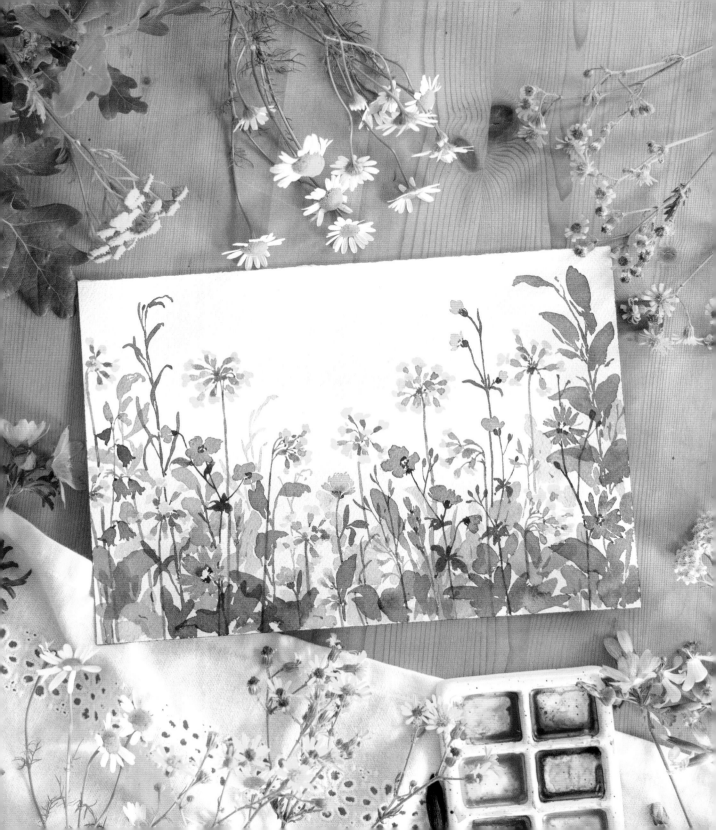

Cowslip

Cowslips are one of the first few early spring flowers. Seeing them pop up in random places always brings a smile on my face as they suggest the end of gloomy, cold winters and the start of warmer days. These yellow nodding flowers come in clusters that stand on thin, upright stems. They have crinkly, tongue-like leaves at the end of their stems. Painting these leaves with swift, loose strokes using a big brush adds a lot of movement to this painting.

COLOR PALETTE

Lemon yellow
Sap green
Quinacridone deep gold

BRUSHES

Size 2 round brush
Size 4 round brush
Size 8 round brush

1. Mix 2 parts lemon yellow and 1 part water to create a thin paste of bright yellow. With the size 2 brush, paint little flowers, forming a circular shape. (See Small Flower Clusters on page 28.)

2. Repeat for another set of flowers. Make sure that these little flowers are pointing in different directions as you paint them. The flowers do not need to have a definite shape but simply need to give the impression of flowers.

3. Mix 3 parts sap green and 1 part lemon yellow, along with enough water to create a thin green mixture. While the flowers are still damp, with the size 2 brush, add conical green ends to the flowers. Allow the green to slightly blend in with the yellow. With the size 2 brush, connect the bunches of flowers with thin, rough lines.

4. Repeat with the other set of flowers. Mix 1 part quinacridone deep gold and 2 parts of the green mix to get a slightly brownish color. Add a thick stem by pressing the size 4 brush fully and pulling it downward.

5. Cowslip leaves are big and ruffled and grow at the base of the plant. Load the size 8 brush (or bigger) completely with the green-brown mixture. Add a lot of water so that the paint moves freely on the paper. Gently press the entire brush down and lift it at a 45-degree angle. Add more such leaves next to each other to create one big leaf. (See A Thick, Ruffled Leaf on page 23.) Repeat to paint another leaf.

6. Paint the other leaves at different angles around the stem. To give it a wild look, try making each leaf look different from the other, and add swift lines and dashes around them.

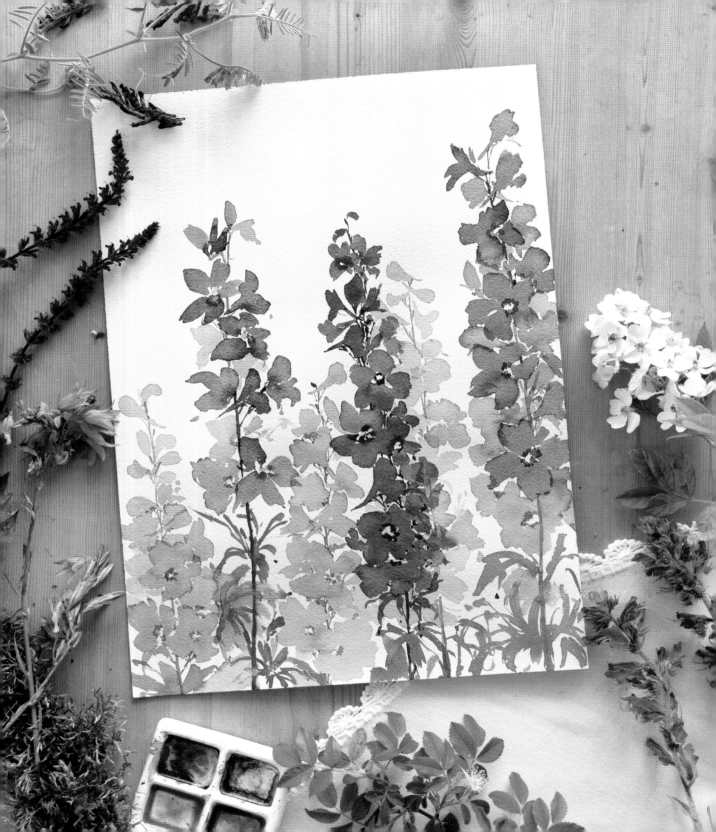

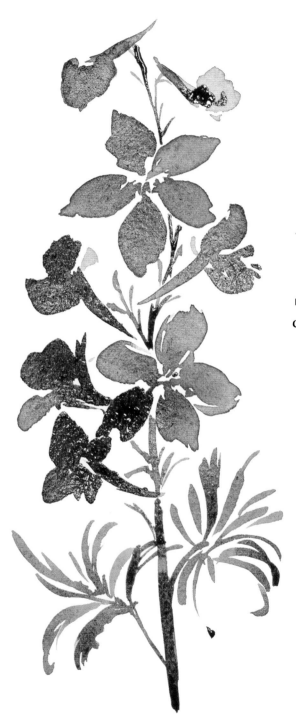

Larkspur

Larkspurs are deep blue or purple flowers that grow in clusters on tall stems. These trumpet or tall-hat wildflowers, which look very similar to delphiniums, are very loosely held on the stem. To paint these, we first use ultramarine blue to show the deep blue colors, and then add drops of dark pink, allowing the two colors to mix on the paper to give us a beautiful purple.

COLOR PALETTE

Quinacridone rose
Sap green
Ultramarine blue

BRUSHES

Size 2 round brush
Size 4 round brush
Size 8 round brush

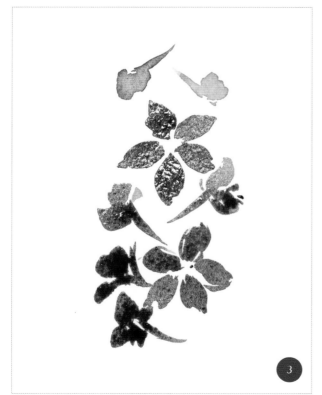

1. Mix 1 part ultramarine blue and 3 parts water to create a watered-down ultramarine blue. With the size 8 brush, paint a thin triangle at the top of the page, and then add a bulb at the end of it. Repeat on the opposite side. These represent the smaller flowers at the top of the plant. (See Hat-Shaped Flower on page 31.)

2. To show the bigger flowers facing us, press the size 8 brush fully to create a petal (similar to painting leaves). Paint these petals all around with sharp ends to form a flower.

3. Repeat to paint another flower at the bottom, and add random, swift, pointed strokes to depict the flowers at different angles.

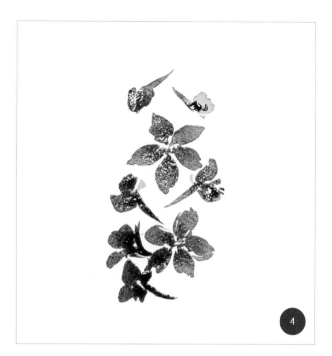

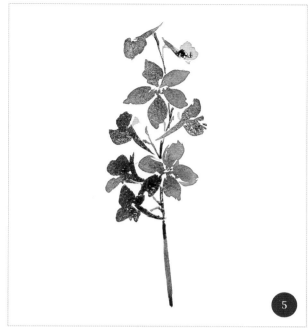

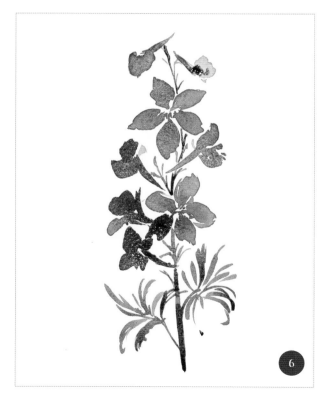

4. Mix 1 part ultramarine blue and 2 parts quinacridone rose, along with lots of water to create a juicy purple. With the size 2 brush, gently add this purple mixture to the wet flowers so that it blends smoothly with the ultramarine blue.

5. Mix 2 parts sap green and 1 part ultramarine blue, along with a little water. With the size 4 brush, add a thin line starting from the top to connect the flowers. As you go down, make this stem slightly thicker by pressing more of the brush onto the paper.

6. With the size 8 brush, paint the leaves. For this, make swift movements with your brush to create a fan-like design at the base. To make the whole bunch look ruffled, make sure that the leaves are different lengths and not stacked neatly next to each other. Add smaller leaves between the flowers on top.

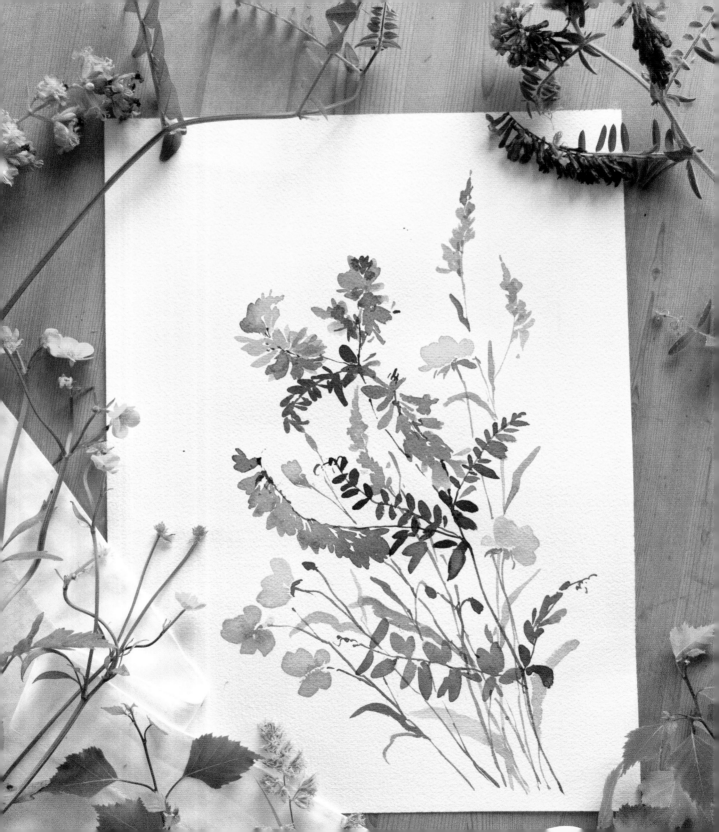

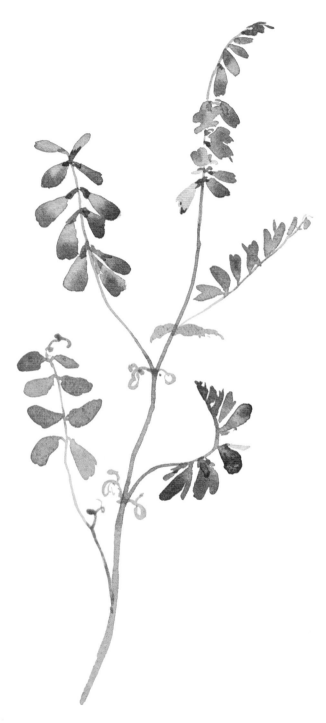

Bush Vetch

Bush vetches are leguminous, lilac-blue flowers that are stacked one next to the other to form a thin line of flowers. Similarly, the leaves are arranged in pairs in a ladder-like fashion. These distinctive features make it easy for us to paint them. I prefer to use a filbert brush here, because by simply pressing the brush at different angles, we can paint flowers and leaves of varying sizes without any elaborate strokes.

COLOR PALETTE

New gamboge
Quinacridone rose
Sap green
Ultramarine blue

BRUSHES

Small filbert brush
Size 2 round brush

1. Mix 2 parts ultramarine blue and 1 part quinacridone rose, along with lots of water, to create a thin purple mixture. Paint two gentle strokes by pressing the thinner side of the small filbert brush onto the paper. These depict the little flowers at the top.

2. Repeat as you go down, adding more flowers on both the left and right sides. Vary the direction of the flowers by pressing the brush at different angles. Vary the gaps between the flowers so that they do not look symmetrical.

3. Prepare a darker purple mixture by adding more ultramarine blue and some water to the previously mixed purple. While the petals are still wet, with the size 2 brush, gently add this to the ends of these petals and allow it to gently blend with the initial color.

4. Create more sets of flowers using the same colors and techniques. Try changing the angles of the petals so that each cluster of flowers looks different. Wait for the flowers to fully dry.

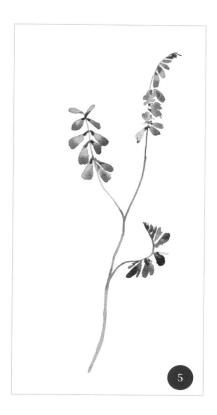

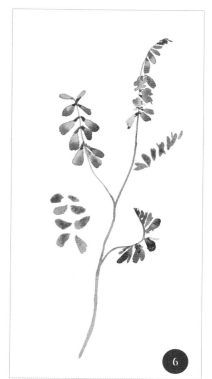

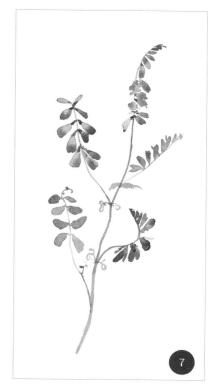

5. Mix equal amounts of sap green and new gamboge, along with a few drops of water, to create a thick green mix. With the size 2 brush, connect the flowers with thin stems. Make sure the stems are a little wonky and curled so this looks like a climbing plant. Add little green ends to each of the petals as you connect them to the stem. At the upper ends of the flowers, add little green lines, similar to painting the flowers but with green to depict the buds that haven't bloomed yet.

6. Painting the leaves is quite similar to painting the flowers. Load the small filbert brush completely with the green mix and gently press it to the paper to create leaves at different angles. (See Small Oval Leaves on page 23.)

7. With the size 2 brush, connect these to the main stem. Add little swirls near the leaves and where the stems intersect with the size 2 brush. These represent the tendrils that the plant uses to climb and support itself. To do this, hold the thin brush almost perpendicular to the paper and gently turn it around while barely touching it to the paper.

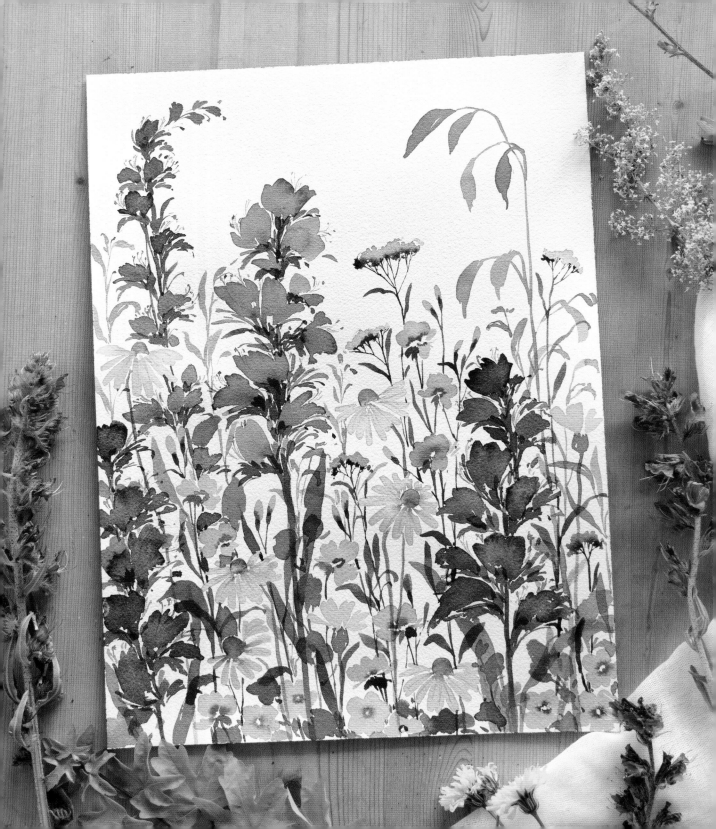

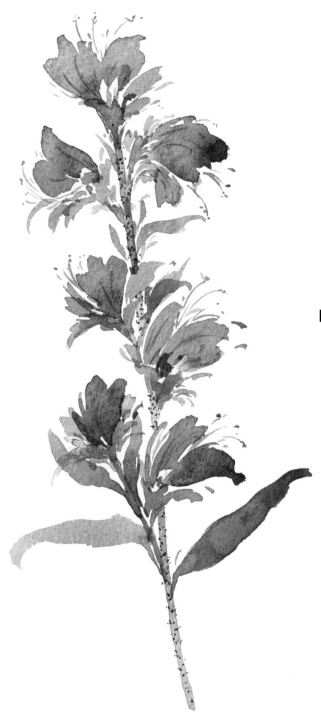

Viper's Bugloss

Viper's bugloss is a hairy plant with vivid purple and pink, densely spiked, funnel-shaped flowers. Although they may seem ordinary, when you look closely, the gorgeous purple and the bright pink stamens and pollen that peek through the flowers make it very attractive. They are known to be the best plants for bees as they are loaded with nectar and keep producing nectar all through the day, unlike other flowers. To show the spiked, funnel shapes of these flowers, we will paint swift, upward strokes with a round brush while trying to be very spontaneous throughout the process.

COLOR PALETTE

Quinacridone rose
Sap green
Ultramarine blue

BRUSHES

Size 2 round brush
Size 4 round brush
Size 8 round brush

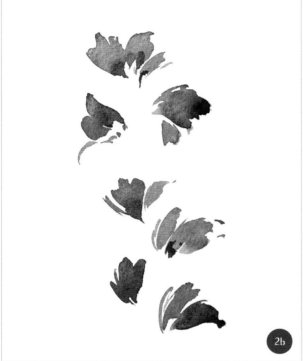

1. Mix 2 parts ultramarine blue and 1 part quinacridone rose, along with lots of water, to create a juicy purple. With the size 8 brush, paint swift, upward movements several times for a flower with ruffled ends.

2. Repeat as you go down, and make the flowers slightly bigger and more ruffled as you go. Add a few lines and little dashes around the flowers to make the painting more dynamic. While the flowers are still wet, use the size 4 brush to add quinacridone rose at the lower ends of the flowers, and allow it to blend with the purple. Wait for all the flowers to completely dry.

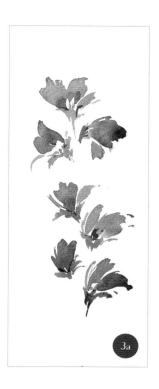

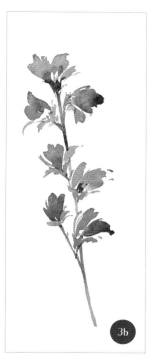

3a

3b

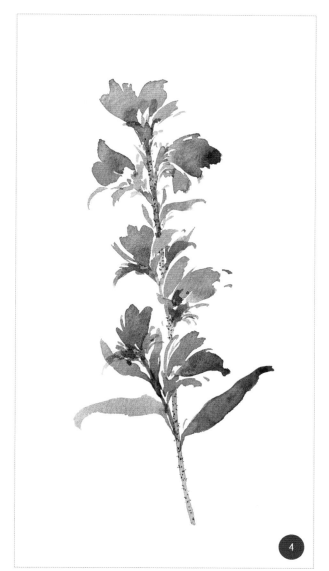

4

3. Mix equal parts sap green, ultramarine blue and water to get a cool green. Once the flowers are fully dry, with the size 4 brush, paint swift short lines under the flowers for the short leaves. Paint a thick line in the middle for the main stem. Connect all the flowers to this stem with the same green mix. Wait for the painting to fully dry.

4. Add bigger leaves using the size 8 brush and the sap green and ultramarine blue mix. Point the leaves in different directions, and allow them to bend slightly downward. Add smaller pointed leaves between the flowers as well. (See A Simple Pointed Leaf on page 21). To make the stem look thorny, with the size 2 brush, add little dots all over the stem. Add a few short, spiked leaves here and there to make the plant look rugged and hairy.

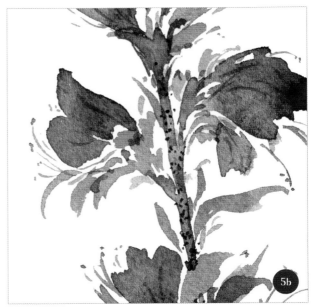

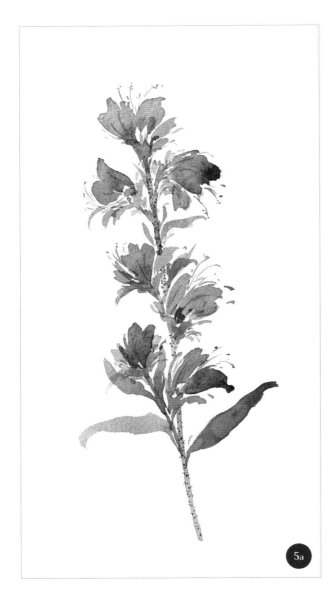

5. Mix 1 part quinacridone rose and 2 parts water to create a thin paste. With the size 4 brush, add little strokes close to the purple flowers to depict the buds. Paint thin, swift lines and dots at the top of the flowers with the size 2 brush to show that the bright pink stamens are peeking out. With the same brush, add thin lines of purple over the flowers to add some texture to the petals.

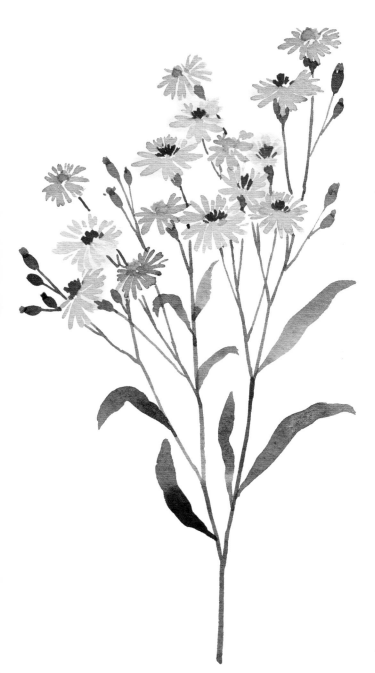

Aster

Wild asters are among the last flowers to bloom, late in summer, coloring the landscape with beautiful shades of purple when the rest of the flowers have all withered away. These charming flowers are great fillers in bouquets and also look great just on their own as a bunch. Here we paint a few asters with golden-brown centers and a few with yellow centers to show the older and the younger flowers. To show the soothing color of these flowers, we add a lot of water to get a light purple tone.

COLOR PALETTE

New gamboge
Quinacridone rose
Perylene green
Ultramarine blue
Quinacridone deep gold
English red

BRUSHES

Small filbert brush
Size 2 round brush
Size 4 round brush

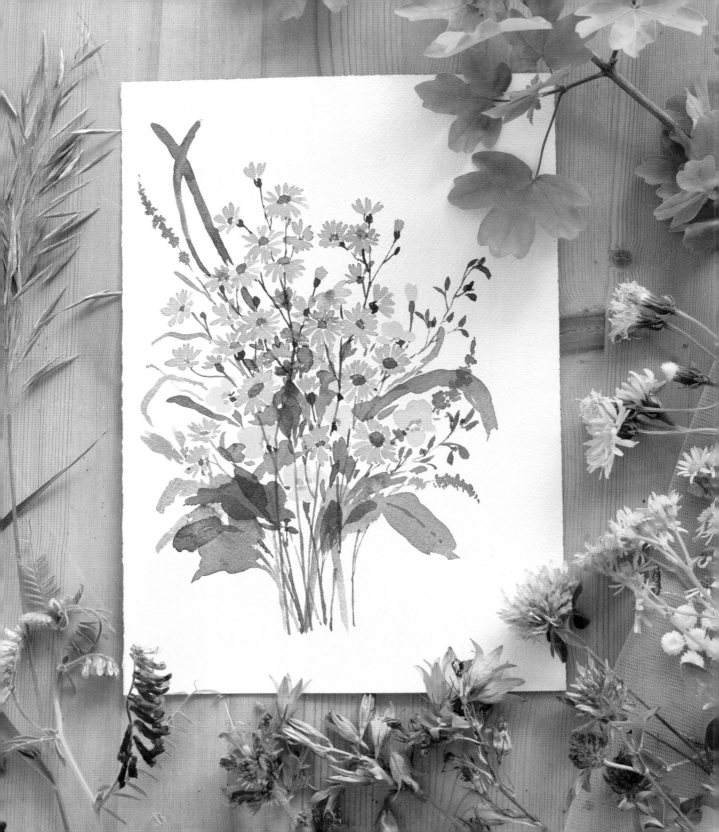

1. Mix equal parts of quinacridone deep gold and English red, along with just a few drops of water, to get a thick golden-brown mixture. With the size 2 brush, add small lines to form little semicircles all across the paper. These will be the flower heads.

2. Wait until the colors are fully dry. Mix 2 parts ultramarine blue and 1 part quinacridone rose, along with a lot of water, to create a light purple color. Using the thinner side of the small filbert brush, paint little strokes under the brown marks. Continue painting all around it with varying thickness to create a flower.

3. Repeat around all the brown centers to create more flowers. Don't worry about making every petal symmetrical. It is preferred if they are slightly random and loose. This adds to the wild look of the flowers.

4. Let's add a few more flowers to make the whole bunch look thicker. This time add some variety and show younger flowers. For this, use a thick paste of new gamboge, and with the size 2 brush, add little brush marks at several spots around the flowers. Wait for these to completely dry.

5. Mix 2 parts ultramarine blue and 1 part quinacridone rose, but with less water, to create a darker purple than before. With the thin side of the small filbert brush, add little strokes around the yellow centers to form the flowers.

6. Once the flowers have fully dried, mix 2 parts perylene green and 1 part quinacridone deep gold, along with a little water, to create a thick paste. With the size 2 brush, add little conical ends at the base of some of the flowers. Connect the flowers with thin lines by gently pulling the brush downward from the flowers. Make elongated V-shaped designs for the stems in order to make several flowers meet.

7. With the same perylene green and quinacridone deep gold mix, use the size 2 brush to add little oval shapes between the flowers to represent the buds. Join them with similar stems, until the whole bunch meets at the bottom with a thin long stem.

8. Add long, thin leaves with the size 4 brush by gently pressing the entire brush onto the paper and slightly wiggling it as you pull it upward. (See A Simple Pointed Leaf on page 21.) Make sure that the leaves closer to the flowers are smaller and the leaves at the bottom are bigger. Mix 2 parts ultramarine blue, 1 part quinacridone rose and a few drops of water. Once the whole painting is dry, use the size 2 brush to add little purple strokes above the green oval buds to show that the flowers are peeking through and ready to bloom.

Composition:
Composing a Floral Bouquet

Having learned how to paint a variety of individual flowers, we can now dive a little deeper and learn to bring them together to create beautiful, wild bouquets. Before painting a bouquet, a bit of planning and preparation need to go into the process. This will help you to paint lush, colorful bouquets without getting too overwhelmed.

1. **Choose Your Flowers:** Just like choosing flowers in a flower shop, select two (or three, maximum) primary flowers that you want in your bouquet. These flowers should preferably be different shapes and sizes. For example, you could pick anemones and delphiniums, roses and forget-me-nots, dahlias and cosmos and so on.

2. **Start by Painting Your Focal Flowers:** Now that you have chosen your main flowers, pick the bigger one of the two. These will be your first focal flowers and the start of your bouquet. Paint these flowers around/near the center of your paper. Adding these big flowers on the sides of the bouquet will make them look droopy and heavy.

Tip: Remember to avoid adding an even number of flowers of the same size, as this makes the arrangement look too symmetrical. Place them in a zigzag or S shape over the entire paper. This helps guide the eyes and tells the viewer where to look, instead of just focusing on one flower at the center.

3. **Paint the Second Set of Flowers:** Add these flowers at different heights between the focal flowers and allow some of them to stand out taller than the bigger flowers. This adds some amount of focus to these secondary flowers.

4. **Filler Flowers:** These flowers are used to fill the empty spaces within the bouquet. They also give structure to the bouquet without taking up too much attention. A lot of wildflowers are used as fillers in bouquets—for example, forget-me-nots, asters, baby's breath and buttercups.

Tip: Make sure to include fillers of a lighter color than the focus flowers so they do not grab attention away from the main flowers. For example, you do not want to use red filler flowers when your main focus flowers are peach or white, as this would make the fillers more striking than the focus flowers.

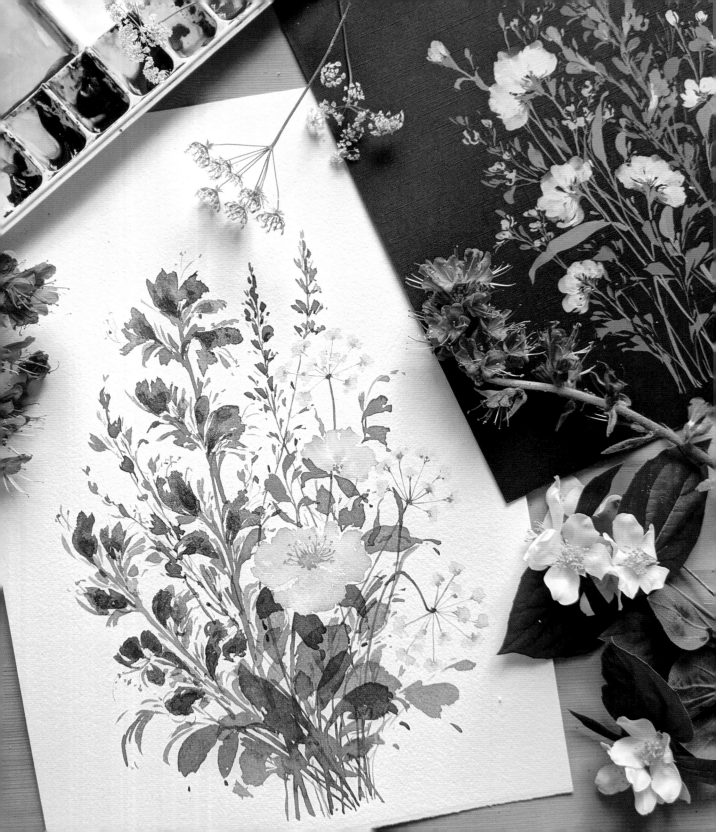

5. **Accents:** Use twigs, grass-blades or leafy branches to add whimsy and give direction to the bouquet. Additionally, they also add height and texture to the whole bunch.

6. **Leaves:** Most leaves are seen at the bottom of the bouquet and are an essential part of making the bouquet look natural. Layer the lower part with several leaves of different colors and shapes, starting with lighter leaves, and then adding darker leaves as the lighter ones dry. This helps create a sense of depth.

Tip: Just like the accents, leaves can also add texture and movement to the painting. Make the leaves spill out on both the left and right sides to show that it is a wild and thick bouquet.

CHOOSING COLORS FOR YOUR BOUQUET

You can choose the color composition of your bouquet in two ways:

1. You can be methodical about your color scheme and choose based on the color wheel in two ways.

In this painting, the pink wild roses are the first focus flowers, and the purple viper's bugloss are the secondary focus flowers. The subtle white cow parsleys are the filler flowers, and the tall green stems and grass-blades are the accents. These help give a shape to the entire bouquet, and their varying shapes and sizes add interest to the painting. The layers of different colored leaves at the bottom show that it is dense and wild, and add depth to the painting.

a. Choose colors that are complementary, like yellow and purple, red and green, etc. This will make the different colors pop against each other.

b. You could choose monochromatic or analogous colors, which show different hues of the same color or two or more colors close to each other on the color wheel. For example, pink and purple, yellow and orange, blue and violet, etc.

2. You can select flowers based on what colors are generally found together in nature, for example red and blue (poppies and cornflowers mostly grow together), or based on what feels soothing to your eyes. If choosing the colors based on the color wheel feels too overwhelming, simply trust your instinct and go with the colors that bring you joy and a sense of warmth. Think of it like you are picking flowers in a flower market. Think about the colors that would catch your eyes among the array of colorful flowers.

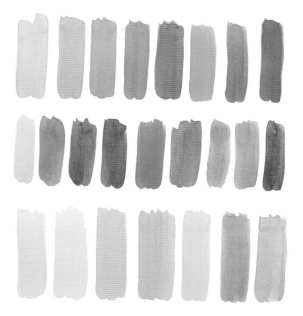

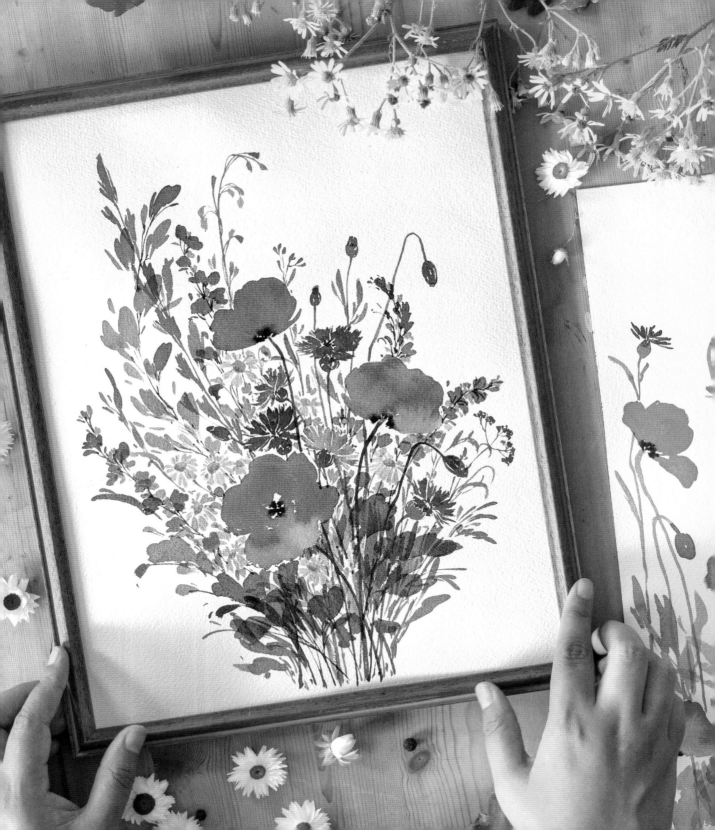

Wild Poppies and Cornflowers Bouquet

Having practiced the basic composition principles, we dive deeper with this bouquet by adding several different types of filler flowers and leaves. With this bouquet we can also understand how we can make the main flowers stand out and be the center of attention, even when the bouquet is dense and wild.

COLOR PALETTE

New gamboge
Quinacridone rose
Pyrrol scarlet
Sap green
Perylene green
Ultramarine blue
Quinacridone deep gold
Sepia

BRUSHES

Big filbert brush
Size 2 round brush
Size 4 round brush
Size 8 round brush

FLOWERS

Focus Flowers
Poppy
Cornflowers/Bachelor's Button

Filler Flowers
Ragwort
Ground Ivy

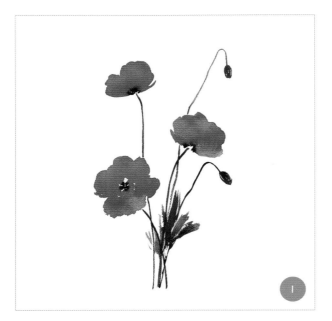

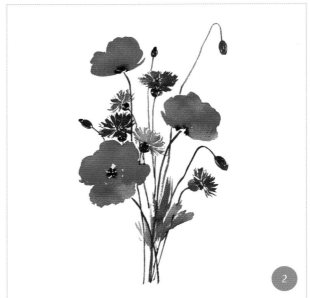

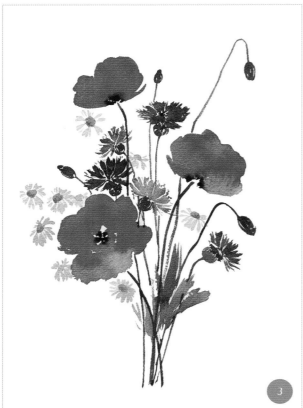

1. Paint the flowers that you want to display prominently and be the focus of your painting. In this case, it will be the big and bright red poppies. Refer to Poppy on page 111 to paint the flowers, the drooping green buds, their long, curved stems and the ruffled leaves. The drooping buds and the tall stems are very essential to add movement to this wild bouquet.

2. Paint cornflowers between the poppies. These will be our second set of focus flowers. Refer to Cornflowers on page 41 to learn in detail how to paint the blue cornflowers and their buds.

3. Add a few yellow daisies, similar to painting asters, but with yellow petals, using a thick paste of new gamboge. Refer to Aster on page 151 to learn the techniques to paint these flowers.

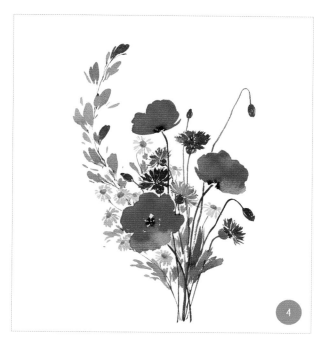

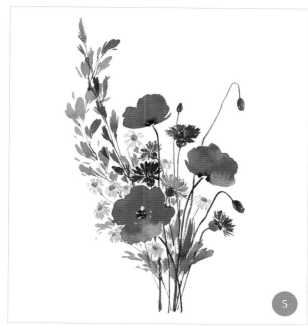

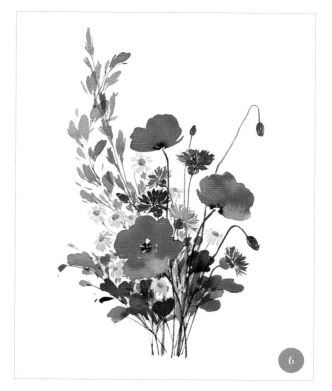

4. Mix equal amounts of sap green and quinacridone deep gold. To add some height, use the size 4 brush to paint a long, leafy stem on the left side. Add a few leaves at the bottom of the bouquet. Wait for it to fully dry. (See A Round, Elongated Leaf on page 22.)

5. To add to the wildness of the bouquet and to show depth, add another leafy branch overlapping the previous one, using the size 4 brush. For this, use a thick mix of quinacridone deep gold, to keep it on the warmer side. (See A Thick Ruffled Leaf on page 23.)

6. Make the base of the bouquet denser by adding a few darker leaves of varying sizes, pointing out on both the left and right sides. Use the big filbert brush with a thick paste of perylene green.

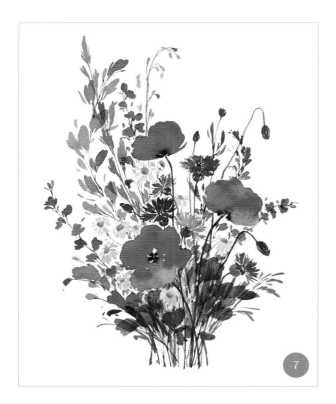

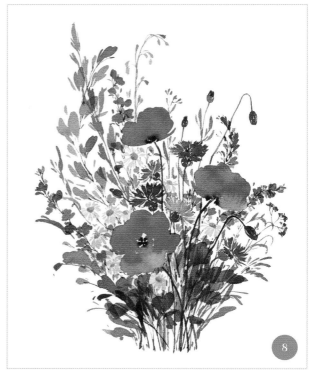

7. Add more filler leaves pointing in different directions. Some leaves can droop, while others can point upward. Use different green and brown mixes of your choice for this part. (See Mixing Green on page 12 for more details.) The bouquet is complete at this point and we can stop working on it. But if you wish to add a few more details to make the bouquet look wilder, follow the next step.

8. Add a few twigs and leaves of different shapes in the empty spaces between the flowers. Add tiny pink flowers between the leaves using quinacridone rose. Add more leaves at the base, to create more depth with layers of leaves.

Note of Thanks

This book would not be what it is without the support of my dear husband, Pratik. As a creative person, my mind is constantly filled with ideas and new things that I want to work on. At times, these thoughts can be chaotic and overwhelming. Using his knowledge of writing research papers, Pratik has helped me tremendously to streamline this chaotic thought process into the words that formed this book. I am also grateful for his support and constant motivation and our frequent long discussions on experimenting and doing what we love without expectations. This has greatly helped me enjoy the process of painting, exploring and writing this book.

I would like to thank my dear friend Ameena Junaize, a fellow botanical artist, for our long discussions about the challenges that beginner artists face while painting and how I can help them through this book.

A special thanks to Lauren Knowles, the kind and patient editor at Page Street Publishing who helped me at every step of writing this book. And thank you to the creative director, Meg Baskis, for bringing my paintings together in a colorful and whimsical way and making this book look so gorgeous! Thank you also to Joe Rhatigan for meticulously copyediting the book and adding the finishing touches.

A special mention to my Instagram family, who constantly shower me with kind words of appreciation and who support me in many ways in my creative journey.

About the Author

Sushma Hegde is a self-taught artist, illustrator and author based in a little town in Luxembourg. She enjoys expressing herself through painting a variety of flowers and landscapes. Her work is largely inspired by the nature and wilderness around her. She loves being outdoors, and you can often find her going on hikes with her paint supplies and starting a painting session when inspiration strikes. Apart from painting, Sushma loves nature photography and spends a fair amount of her morning clicking pictures of the countryside and of the wildflowers she finds on her walking route.

Sushma enjoys teaching and sharing her knowledge with fellow creatives and art enthusiasts. She teaches watercolor floral and landscape classes on Skillshare, where more than 10,000 students have taken her classes. She works toward simplifying and demystifying the process of painting to encourage more people to find joy in creating art.

Her work can be found on her website (www.sushmahegde.com) and on Instagram (@sushhegde). Apart from sharing process videos, and glimpses of her studio life, she also regularly shares painting tips and tricks, fun experiments from her studio and photos from her nature walks and travels. You can connect with her on Instagram and share what you learned from this book using the hashtag #wildflowerswithsush or #wildflowerwatercolor.

Index